Calligraphy
MADE EASY

GAYNOR GOFFE

A COMPLETE BEGINNER'S GUIDE

COVER FRIEZE:
GAYNOR GOFFE

FRONT COVER LETTERING:
STEPHEN RAW

First published in Great Britain in 1994 by
Parragon Book Service Ltd
Unit 13–17
Avonbridge Trading Estate
Atlantic Road
Avonmouth
Bristol BS11 9QD

This edition published 1996

Copyright © 1994 Parragon Book Service Ltd

ISBN 0-75252-055-5

Printed in Great Britain

Design: Crump Design
Editors: Alexa Stace and Linda A. Doeser
Special Photography: Steven Bartholomew

Contents

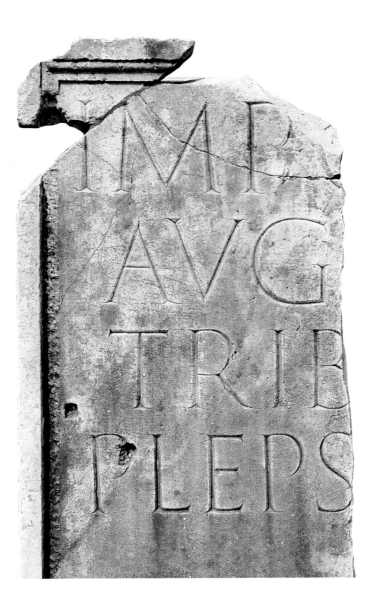

4

Quel dolce suon; per cui chiaro s'intende
 Quanto raggio del ciel in uoi riluce;
 Nel laccio, in ch'io gia fui, mi riconduce
 Dopo tant'anni; et preso a uoi mi rende.
Sento la bella man; chel nodo prende
 Et strigne si; chel fin de la mia luce
 Mi s'auicina, et chi di fuor traluce,
 Ne rifugge da lei, ne si disende:
Ch'ogni pena per uoi gli sembra gioco,
 E'l morir uita: ond'io ringratto Amore;
 Che m'hebbe poco men fin da le fasce:
E'l uostro ingegno; a cui lodar son roco:
 Et l'antico desio; che nel mio core,
 Qual fior di primauera, apre et rinasce.

Cosi mi renda il cor pago et contento
 Di quel desio, ch'in lui piu caldo porto;
 Et colmi uoi di speme et di conforto
 Lo ciel quetando il uostro alto lamento:
Com'io poco m'apprezzo, et talhor pento
 De le fatiche mie; chel dolce et scorto
 Vostro stil tanto honora: et sommi accorto,
 Ch'amor in uoi dritto giudicio ha spento.
Ben son degni d'honor gl'inchiostri tutti,
 Onde scriuete; et per le genti nostre
 Ne ual grido maggior, che suon di squille.
Pero s'auen ch'in uoi percota et giostre
 L'empia fortuna; i sospir uostri e i lutti
 Si raro don di Clio scemi et tranquille.

Historical introduction

Although we live in a high-tech world, calligraphy is still relevant today: the recent upsurge in its popularity reflects the fact that designing and making things by hand is an intrinsic part of our creative nature.

Writing has a long, complex history, reflecting the rise and fall of civilizations. From the earliest cave paintings to picture symbols such as Egyptian hieroglyphs, to the Phoenician alphabet and eventually to our alphabet – a Roman adaptation of the Greek alphabet – writing has expressed thoughts and feelings in a personal way and in a variety of media: inscribed on clay tablets, carved in stone, written with reed pens on papyrus or with quills on animal skin. Though calligraphy today is continually pushing forward the artistic boundaries, the raw material remains the letterforms of the past, and an appreciation and understanding of this rich cultural heritage is important.

The Roman period remains a major landmark in the development of the letterforms of western civilization. Although there were pen-made Roman Rustics and square capitals, they were rather complex to write and we still look to the finest carved inscriptional Roman capitals as reference for pen-made capitals. Their weighted forms are similar to pen-made capitals, because Roman inscriptions were painted out with a wide, flat brush, producing thick and thin strokes in the same way as an edged-pen.

Writing styles did not suddenly stop when new scripts developed. It was an overlapping process, and earlier scripts often continued in use in manuscripts, particularly as headings and initials: this happened with Roman Rustics. Throughout history there has been an evolution of everyday handwriting alongside major formal scripts, and this has played an influential part in the development of western scripts for over 2000 years.

Roman cursive handwriting greatly contributed to the emergence of Uncial, Half-Uncial, and other Anglo-Saxon scripts. These were used through the Dark Ages from the 5th to the 7th centuries and in some cases later. Beautiful illuminated manuscripts were made in association with the spread of Christianity and the Half-Uncial scripts reached a peak in the finely written and decorated 7th-century Lindisfarne Gospels and Irish Book of Kells.

After the Dark Ages, a script developed which was to have a great influence on modern calligraphy. This was a 10th-century roundhand: an English development from the French Carolingian minuscule, very important in the evolution of scripts. Edward Johnston, who revived calligraphy at the beginning of the 20th century, based one of his main teaching hands – Foundational – on the 10th-century Ramsey Psalter, prized for its legibility. It is a well-known hand to those beginning calligraphy today.

Like changes in architecture, writing characteristics gradually changed from the round Norman arches of the 9th and 10th centuries to the pointed Gothic arches of the 11th to 14th centuries, and compressed, angular scripts developed, such as Blackletter and Gothic Cursive.

The Italian Renaissance of the 15th and 16th centuries marks a further landmark in the evolution of writing. With a renewal of interest in the classical past there was a revival of Roman letterforms and 9th-century Carolingian minuscule for manuscript use. A combination of factors, including speedy writing of round Renaissance minuscule for business purposes, together with the influence of everyday handwriting, resulted in the development of Italic: a compressed, sloping, flowing script, and one of the most versatile and useful scripts for the modern calligrapher. Although the invention of printing greatly reduced demand for hand-made books, fine writing continued. Calligraphic virtuosity reached a peak in the writing manuals of the Renaissance writing masters, so that today there is a wealth of designs to draw upon.

In the post-Renaissance period, Copperplate pointed-pen writing emerged from Italic scripts and took over from edged-pen writing, which was virtually unused again until William Morris produced his beautiful illuminated Italic manuscript books during the Victorian Arts and Crafts revival. Following this Edward Johnston, the father of 20th-century calligraphy, re-established the craft through historical research and investigation into the making of edged-pen letterforms.

The whole modern calligraphy movement stems from this re-awakening to the possibilities of an ancient craft in a modern context. The early 20th-century revival was largely confined to England, Germany and the United States, but since the 1960s interest has spread to other European countries, and even further afield to Russia, Australia and South Africa. The resulting international interchange of ideas has vastly enriched calligraphy, and an increasing number of people are finding satisfaction in this versatile medium.

Opposite left, Beautiful classical Roman carved inscriptional capitals from the Roman Forum. Photo: Anna Ronchi

Opposite right, A very finely written Renaissance Italic, Bembo's sonnets. Victoria and Albert Museum.

Tools & materials

There is an ever-expanding range of tools and materials available to the calligrapher today, including multi-stroke pens, coloured inks and acrylics, various gilding media and attractive hand-made papers using plants such as hemp, straw, tea, algae, with subtle textures and colours.

It is interesting as you progress and investigate new ideas and techniques, to gradually add to your range of tools and materials and calligraphy provides an exciting challenge for their creative combination.

A3 layout pad

scalpel

Saunders Waterfood

BFK Rives tan

BFK Rives cream

BFK Rives grey

Fabriano Ingres coloured papers

poster pen nibs

size 18

size 19

size 20

nibs with slip on reservoirs

2½

3

3½

4

5

6

1½

2

1

0

disposable craft knife

range of square-cut *roundhand* nibs sizes 0 – 6

left oblique *roundhand* nibs

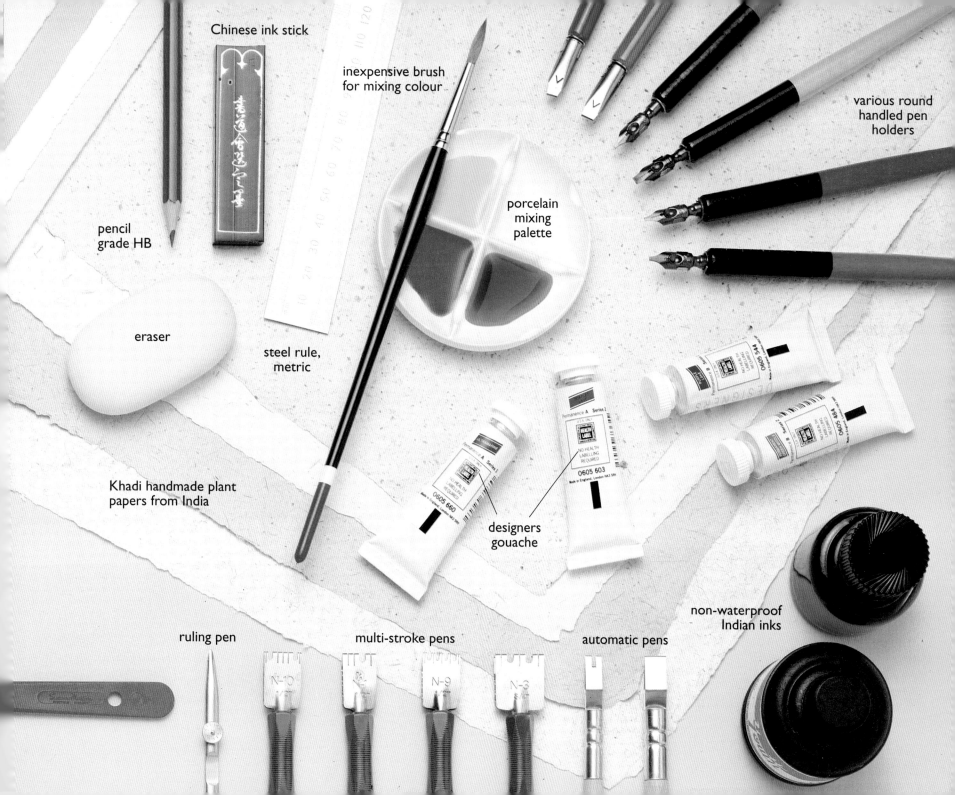

Chinese ink stick

inexpensive brush
for mixing colour

various round
handled pen
holders

pencil
grade HB

porcelain
mixing
palette

eraser

steel rule,
metric

Khadi handmade plant
papers from India

designers
gouache

non-waterproof
Indian inks

ruling pen

multi-stroke pens

automatic pens

N-0

N-9

N-3

Tools and materials

Pens and nibs

Use a dip pen – the flexible nib encourages rhythmical writing. They can be used with gouache, watercolour or ink.

Penholders Most have a cylindrical barrel. The nib should be pushed in securely. Avoid ones with attached reservoirs.

Reservoirs The fitment should be separate from the penholder and fitted to the underside of the nib with the tip 3mm (⅛in) from the end of the nib. They are often too tight, restricting the ink flow; make sure it can be easily moved up and down the nib. Loosen the clips if too tight, squeeze them together if too loose. The tip of the reservoir should be in contact with the nib. (see figure 1).

Nibs Rexel roundhand nibs sizes 0–6 can be used for all edged-pen scripts, square-cut for right-handers and left-oblique for left-handers. New nibs are sometimes greasy: hold the nib in a match flame for a few seconds. Always wash and dry nib and reservoir after use.

Automatic and coit pens Useful for large-scale writing. There are various sizes, with single and multi-stroke nibs. Large nibs encourage arm movement and rhythm when writing.

Inks and paints

For black ink either bottled non-waterproof Indian ink or Chinese ink is suitable. Waterproof ink does not give really sharp strokes. Dip the nib into the ink, shake off the surplus and wipe the front of the nib on tissue. To feed the nib with a brush instead of dipping, fill from the underside, ensuring the ink goes between the nib and reservoir, and shake to remove surplus ink. (see figure 1)

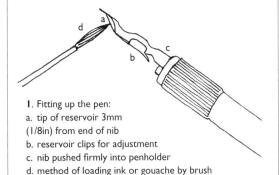

1. Fitting up the pen:
a. tip of reservoir 3mm (1/8in) from end of nib
b. reservoir clips for adjustment
c. nib pushed firmly into penholder
d. method of loading ink or gouache by brush

Paint For writing in colour, use gouache, mixed with water and a paintbrush to the consistency of thin cream. Feed into underside of nib with a brush as with ink. Gouache gives opaque writing: for a translucent paint mix tube watercolour in the same way as gouache. Permanence A or B are preferable.

Solving problems:
1. Strokes feather on one side: due to uneven pressure on the nib edge. Press down more on the same side of the nib as the feathered stroke edge.
2. Gouache feels greasy and will not flow properly: it is probably too thick. Dilute, stir thoroughly and wash out nib and reservoir.
3. Blobby letters: the pen may be over-filled. Shake surplus ink or paint out after filling. The reservoir may be too near the end of the nib, allowing the ink or paint to run too freely; move it further back. The gouache may be too runny: add more and stir thoroughly.
4. Ink or gouache fails to give a full stroke width: the reservoir is probably too tight. Remove and loosen side clips.
5. If the pen will not start writing, move the nib from side to side on the spot in the direction of the thin edge of the nib and press to encourage the ink to flow.

Paper

The choice ranges from fine quality, hand-made or mould-made papers to less expensive machine-made papers and interesting Japanese and Indian papers.

Types
1. Handmade paper is made in individual sheets with deckled edges.
2. Mould-made paper is made in separate sheets by machine. Sheets have two deckle and two cut edges.
3. Machine-made paper is made in one continuous roll and cut to sheet size.

Surface Surface finish is important. HOT-PRESSED paper is the smoothest, and the most widely used. NOT paper may be lightly pressed, but is less smooth than hot-pressed paper. ROUGH paper has not been pressed

2. Writing trials on different paper surfaces:
a. mould-made, hot-pressed, smooth
b. machine-made, smooth
c. handmade, smooth but slightly fibrous straw paper
d. mould-made, slightly textured
e. mould-made, rough
f. handmade, rough

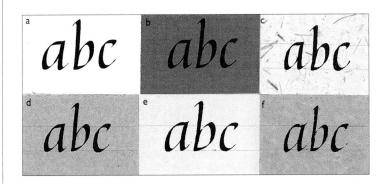

and has a textured surface, more suitable for an edged-brush or a large coit or automatic pen.

Grain direction Handmade paper has no grain direction, but machine-made paper does. It is important to identify the grain direction, particularly for manuscript books where the double pages should lie open comfortably, and the grain direction should align with the spine.

Sizing Most papers have size added during manufacture preventing ink or paint from spreading and encouraging sharp writing.

Weights and sizes Avoid too thick paper for a manuscript book, where the double page opening should lie nearly flat. Weight is measured in grams per square metre (gsm). A suitable weight for a manuscript book would be 90 – 120 gsm.

Try out paper samples and make notes – useful for future reference (see figure 2). Try both front and back as the surfaces vary. Always store paper flat in a drawer.

Gum sandarac Finely ground resin applied to paper for increased writing sharpness. Store in a small lidded jar and brush over the paper with a large paintbrush.

Pumice Pumice powder helps writing on a greasy or shiny surface. Store and use in the same way as gum sandarac.

The writing board (see figure 4)

Writing on a 45° incline gives optimum ink flow and a comfortable writing position. Tape down cartridge or layout paper to pad the board and give a yielding writing surface. Fold a guard sheet of layout paper length-ways and tape at either end fold uppermost, at a convenient height, so the hand rests on it while writing. This holds the work in place and keeps grease off.

Sitting position Sit square to the drawing board with feet flat on the floor and your non-writing hand resting on the work a few inches from the writing hand. This takes pressure off the writing hand.

Lighting It is essential to use an adjustable reading lamp, placed on the right for left-handers and on the left for right-handers.

Penhold Figures 3a and 3b show the hand position for right and left-handers. For right-handers the forefinger should be convex and the penholder should point over the right shoulder; for left-handers the forefinger should be concave due to the extra pressure exerted to grip the pen and the penholder should point towards your chin.

Hints for left-handers

1. Use left-oblique nibs, which makes it easier to obtain the steeper pen angles, such as 45° for Italic.

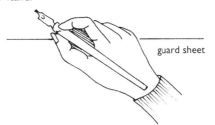

3a. Hand position and pen hold – right-handers

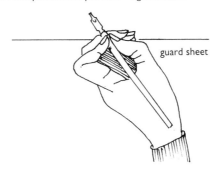

3b. Hand position and pen hold – left-handers

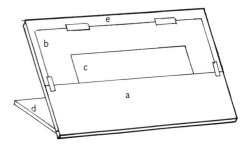

4. Setting up the board:
a. guard sheet
b. padded surface of board
c. loose writing sheet
d. base board
e. writing board inclined at 45° angle

2. Write underarm, with the writing hand below the writing line as right-handers, not in the overarm hook position.

3. Keep your wrist turned back as far as possible and your elbow in, but not rigidly – the writing arm must move freely.

4. Slant the paper slightly down to the right to get the required pen angle, though it is better to keep the paper straight if possible as it is then easier to judge letter slope.

5. Move the writing sheet to your left several times per line

Essential starter kit:

Selection of roundhand nibs
2-3 reservoirs and penholders
Bottle non-waterproof Indian ink
A3 layout pad, pencil, ruler,
tape and scissors
Drawing board
Small mixing palette and brush
Several tubes of designer's gouache
Rubber cement for paste-up

Letterforms

Characteristics

The essential characteristics of an alphabet are determined by a number of factors. The actual parts of a letter are shown in figure 1.

Letter weight (figures 2, 3, 4): Created by using an edged tool to produce two overlapping skeleton letters (figure 2b), and is expressed as the letter body height measured in nib-widths. This is termed the x-height. To measure the x-height keep the nib edge vertical (figure 3a) moving from left to right for each nib-width block. Each script has a given weight, e.g. 5 nib-widths x-height for Italic and 7 nib-widths for Roman capitals. It is essential to use these proportions first; letter weight can later be varied using the same nib, increasing the x-height to make lighter-weight letters, decreasing it to make heavier ones (figure 4).

Pen angle: (figure 5) The angle of the nib to the horizontal writing line helps to determine the character of the alphabet, controlling the distribution of weight round the letterform, i.e. where the thick and thin strokes occur. The nib is held at a flatter angle for round scripts and steeper for compressed scripts (figure 5). Some scripts require a constant nib angle, e.g. Italic; others require changes of nib angle for some letters or parts of letters, e.g. Roman capitals.

The 'o' form: (figure 6) The width, height, weight and slope of the 'o' form is a major influence on the character of the alphabet, especially on the curved parts of letters.

The number, order and direction of strokes per letter: (figure 7) The number of strokes varies from letter to letter. A formal alphabet tends to have more pen lifts and therefore strokes per letter than a cursive where the pen is kept on the paper more, with fewer

1. Parts of the letter:
a. bowl (also enclosing counter space)
b. descender
c. tail
d. ascender
e. arch
f. counter space
g. serif
h. horizontal cross-bar

2. Letter weight:
a. skeleton Italic 'n', no weight
b. double pencil Italic 'n' showing how an edged tool adds weight – it consists of two overlapping skeleton forms
c. pen-written weighted Italic 'n'

3. Letter weight:
a. measuring up
b. Roman capital 'N', 7 nib-widths
c. Italic 'n' 5, nib-widths x-height
d. Foundational hand 'n', 4 nib-widths x-height

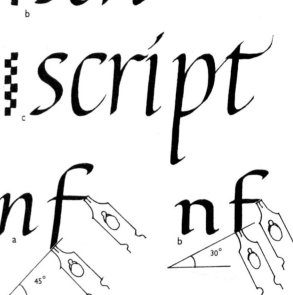

4. Letter weight:
(using Rexel's no 2 nib)
a. heavy weight Italic, 3 nib-widths x-height
b. near-normal weight Italic, 6 nib-widths x-height
c. lighter weight Italic, 8 nib-widths x-height

5. Pen angle:
Note the relative weights of the heavier downstrokes and lighter horizontals produced by holding the pen at a constant angle:
a. 45° for Italic. b. 30° for Foundational hand

6. The 'o' form:
The 'o' relates to other curved letters:
a. compressed pointed 'o' - sharpened Italic
b. compressed smooth oval 'o' - formal Italic
c. 'o' based on two overlapping circles - Foundational hand

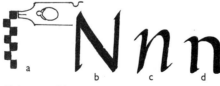

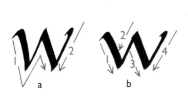

7. Stroke number, order and direction:
a. Italic 'w', only one pen lift
b. Foundational hand 'w', three pen lifts

8. Speed of writing:
a. flowing, quickly written Italic
b. slower, Foundational hand

9. Serifs:
a. oval hooks on Italic
b. sharp serifs on Italics
c. built-up triangular top serif on Italic
d. circular hooks on Foundational hand

10. Slope:
a. angle of slope – approximately 7°
b. slope for formal Italic – approximately 7°
c. more sloping sharpened Italic

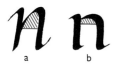

11. Arches:
a. asymmetrical, compressed arch for Italic, springing from stem just above halfway
b. circular arch for Foundational hand, leaving stem high up

12. Ascenders and descenders:
a. Italic ascenders and descenders approximately 3–4 nib-widths
b. height of flourished ascenders and descenders is more flexible
c. Foundational ascenders and descenders approximately 2½ nib-widths

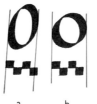

13. 'o' width:
a. compressed 'o' for Italic, approximately 3½ nib-widths wide
b. circular 'o' for Foundational, approximately 4 nib-widths wide

pen lifts. The stroke order must be learned for each letter and is usually left before right. The direction of strokes varies from letter to letter. Push strokes tend to be uphill and to occur in more quickly written alphabets and need lighter pressure on the nib. Pull strokes tend to be downhill or horizontal.

Writing speed: (figure 8). Stately Roman capitals are slowly written; cursive Italic is quick. The nature of the serifs and whether the script is joined or unjoined are further indicators of writing speed.

Serifs: (figure 9) Serifs often relate to the 'o' form of the alphabet. In Foundational they are circular; in Italic, oval. Serifs have a functional role, easing the pen in and out of strokes. Often there is more than one style of serif that can be used with a particular alphabet. Serifs tend to be restrained in a slowly written script, e.g. Foundational, and more exaggerated in a faster script, e.g. Italic.

Slope: (figure 10) This indicates writing speed, upright alphabets being slower than sloping ones. Slope is measured as the angle between a vertical line and the slope of a downstroke (figure 10a). Most alphabets require a uniform slope. It helps to draw parallel, vertical lines on the writing paper to help accurate letter slope.

Arches: (figure 11) The consistency and shape of letter arches is a key feature of a Minuscule script. A Foundational arch is circular with a symmetrical counter shape. It leaves the stem high up, in an 'across, round and down' movement. An Italic arch is compressed and asymmetrical and leaves the stem half to two-thirds up the x-height in an uphill curved push stroke.

Ascenders and descenders: (figure 12) Italic has relatively long ones, whereas Foundational, being a rounder letterform, has shorter ones. They should be measured in nib-widths, like the x-height, and later can be judged by eye. In a free rendering of Italic they may be varied, often with decorative flourishes.

Letter width: (figure 13) This is measured in nib-widths - remember to turn the nib edge to a horizontal position to obtain this particular measurement .

Using the pen

Ruling up

Rule up carefully with a sharp HB, H or 2H pencil. Writing will be more accurate if you rule up on the writing sheet and do not use a pre-ruled grid.

1. First write the correct number of nib-width blocks for the x-height of the required alphabet on layout paper. (See figure 3 page 10 for pen position.) Mark this measurement on the straight edge of a paper strip.

2. Decide the interline space – twice the x-height is a guide for most Minuscule scripts. Mark this interline interval on the straight edge of the paper strip below the x-height mark (see figure 1). Repeat these intervals down the paper strip.

3. Rule one horizontal line about an inch from the top of a sheet of layout paper. Using the marked paper strip, dot in the marks below this down the left then the right sides of the paper. This line will ensure that the marks down both sides of the paper are level.

4. Rule up with a sharp pencil.

Getting the pen working

With the writing board set up, and the layout sheet ruled up and placed loose under the guard sheet, set up the pen, pushing the nib well down the holder and ensuring the reservoir is not too tight. Dip the nib into the ink, or feed with a brush, shake off surplus and wipe the front of the nib.

To make the ink flow readily move the nib edge diagonally virtually 'on the spot' (figure 2). When beginning you may need to do this with each letter. With time you get to know when the ink is going to flow.

Stroke practice

In most scripts the majority of strokes are downhill or horizontal pull strokes: it is easier to pull the nib than push against it. More flowing scripts tend to have more uphill push strokes than slowly written scripts.

It is easiest to practise strokes in the Foundational hand (figure 3 to 11) as this is an upright script, and its vertical downstrokes can be more easily judged than sloping downstrokes of Italic. With double lines ruled to contain the letter bodies, measuring 4 nib-widths x-height of a Rexel's number 2 nib, practise the following strokes:

1. Vertical downstrokes (figure 3a). Space evenly and make the strokes sharp, exerting even pressure on the whole nib edge; ensure it is fully in contact with the paper to avoid ragged strokes. Then try round serifs as they help the flow (figure 3b). Keep pen angle constantly at 30° (figure 4a, b, c).

2. Straight horizontals (figure 5). Practise these next, still maintaining a 30° pen angle. The direction of the strokes automatically makes them lighter in weight than vertical downstrokes.

The red arrows show direction in which the pen moves.

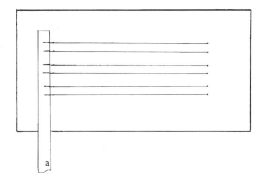

1. Ruling up writing sheet using a paper strip (a) marked with letter x-height and interline space

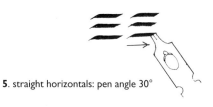

2. Getting the pen started – encouraging ink flow.

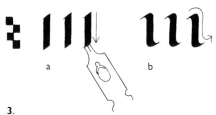

3.
a. vertical downstrokes, pen angle 30°
b. vertical downstrokes with round serifs, pen angle 30°

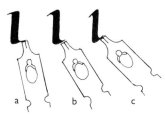

4.
a. pen angle too flat, approximately 10° making verticals too thick
b. pen angle correct: 30°
c. pen angle too steep, 45°, making verticals too thin

5. straight horizontals: pen angle 30°

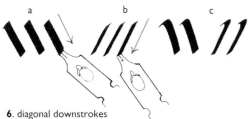

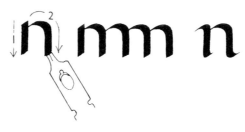

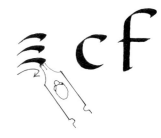

6. diagonal downstrokes
a. thick diagonals, pen angle 45°
b. thin diagonals, pen angle 30°
c. thick and thin diagonals with rounded serifs

8. circular arches, pen angle 30°

10. horizontal top curves, pen angle 30°

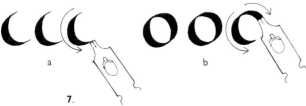

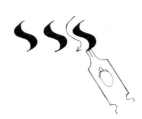

7.
a. anticlockwise circular curves, pen angle 30°
b. complete 'o' with anticlockwise and clockwise curves, pen angle 30°

9. curved diagonals, pen angle 30°

11. horizontal base curves, pen angle 30°

3. Diagonal downstrokes (figure 6a, b, c). Thick diagonals require a steeper pen angle than the rest of the Foundational hand, to prevent them being too heavy. Hold the pen at 45°. Thin diagonals require the pen angle at 30° or they will be too thin.

4. Full height curves (figure 7a, b). Keep both side curves round and smooth, overlapping stroke joins for strength. Look at the inside counter – a fat lemon shape – as well as the strokes when writing. Keep pen angle at 30°.

5. Circular arches (figure 8). Place the nib right inside the stem high up, when commencing the arch. Move in a straight diagonal till the nib emerges from the stem, then move it across to the right, round and down to make a circular arch. Pen angle 30°.

6. Curved diagonals (figure 9). Make a smooth continuous curve; the stroke should

not be thin in the middle. Pen angle 30°.

7. Horizontal top and base curves (figure 10, 11). All horizontal curves in Foundational hand relate to the circle; ensure fine serifs. Use a 30° pen angle.

Problems and solutions:

*Strokes ragged: one edge of the nib is not in full contact with the paper. Press down more definitely on the side giving ragged edge.

*Ink will not flow properly:
a. The reservoir may be too tight.
b. The reservoir may be too far away from the nib end.
c. Greasy new nib – hold nib in match flame for three seconds.
d. If using gouache it may be too thick - dilute further.

*Strokes blobby:
a. Pen may be overloaded – shake surplus out before writing.
b. Writing board may be too flat and ink flow too rapid.

*Strokes 'bleed' on the paper - usually due to incompatibility between ink and the paper. Mix gouache instead of ink or use a different ink or try different paper.

*Strokes are uneven thickness – check the pen angle is consistent. Also, that you are not pressing too hard and making the stroke wider than the width of the nib. Keep the non-writing hand on the board a few inches away from the writing hand, this takes pressure off the writing hand.

*Letter height varies from line to line - check line ruling is accurate and keep letter bodies exactly between the double lines.

Spacing

Three aspects of spacing to consider in calligraphy are letter spacing, word spacing and line spacing. The use of space between and around text areas in a calligraphic design is discussed on page 16.

Letter spacing

Accurate letter spacing is as important as good letterform.

Spacing principles An even-looking space should exist between and inside letters. The area between all letters of any particular script at a given size and weight is the same, although the area within letters varies according to letter shape.

To establish the area between letters for any particular script, write a straight-sided letter such as an 'h' or 'n', then place an 'i' next to it, ⅔ of the counter width away. This is the required area. Because letters are different shapes, to create this same area the letters have to be placed at different distances – straight letters furthest apart, curved ones closest. Continue the diagram, writing an 'o' next to the 'i', placing it a little closer than the 'h'–'i' distance. Finally, place another curved letter next to the 'o' a little closer still.

This 'hioc' diagram should be written for each script as a spacing guide (see figures 1a, b, c, d). Having established the spacing diagram, practise spacing straight-sided letters first, as these are equidistant (figure 2), then try repeating the same few words, checking spacing and re-writing (figure 3). Some letter combinations are more difficult to space than others, depending on the script. Some are shown in figure 4.

Spacing check Each letter should be centred between the preceding and following letters and the area on either side equal. Write a

1. Spacing diagram showing distances between straight and curved letters.
a. Italic.
b. Foundational hand.
c. Roman capitals.
d. Italic capitals.

2. Spacing practice with straight-sided letters.
a. Italic
b. Foundational hand.
c. Roman capitals.
d. Italic capitals.

3. Spacing practice: words
a. Italic.
b. Foundational hand.
c. Roman capitals.
d. Italic capitals.

4. Difficult letter spacing combinations:
a. 'ry' Italic.
b. 'ry' Foundational hand.
c. Adjacent diagonals in Roman capitals.
d. 'TT' in Italic capitals.

5. Spacing between words:
a. Italic.
b. Foundational hand.
c. Roman capitals.
d. Italic capitals.

a *on the* *c* ON THE

b on the *d* ON THE

6. Line spacing: Italic.
a. Close line spacing, one x-height.
b. Wider line spacing, 1½ x-heights.

a In the misty mountains
the clouds hung low
over the sculpted forms

b In the misty mountains
the clouds hung low
over the sculpted forms

7. Line spacing: Roman capitals.
a. Close line spacing, ½ a letter height.
b. Wider line spacing, one letter height.

a IN THE MISTY MOUNTAINS
THE CLOUDS HUNG LOW
OVER THE SCULPTED FORMS

b IN THE MISTY MOUNTAINS
THE CLOUDS HUNG LOW
OVER THE SCULPTED FORMS

long word and check every three letters in this way for spacing, e.g. 'rambling', 'ram', 'amb', 'mbl', 'bli', 'lin', 'ing', re-writing as necessary. The eye reads part of the space in open or semi-open letters with the interletter space, so the spacing of these letters is slightly more difficult to judge in Roman capitals, 'L' 'T' 'C' 'K'.

Word spacing

Leave space for an 'o' of the script being used between words (figure 5). The inter-word space needs to be carefully considered when letters ending and /or beginning a word are open or semi-open letters.

Line spacing

This is called interlinear spacing and the amount of interlinear space depends on the style, weight, size, length of writing lines, amount of text and the vertical texture required to suit the text. A Minuscule alphabet will need enough interlinear space to clear the meeting of ascenders and descenders.

Generally, a script with long ascenders and descenders, e.g. Italic, will need more space than one with shorter ones, e.g. Foundational hand, though the effect you want may even involve lines of text merging – there are guidelines to follow but no hard and fast rules.

Line lengths affect interlinear spacing: longer lines generally require wider line spacing than short ones. A line spacing guide for texts written in Minuscule is 2–2½ x-heights for long lines, and 1½–2 x-heights for short lines. Texts written in Majuscule (capitals) can have closer line spacing as there are no ascenders and descenders.

General principles of layout

Layout is the arrangement of design elements within a certain space. A calligraphic layout involves writing out the text, cutting into lines, arranging them and pasting up. This is used for reference when writing the final version or as artwork for print.

Layout is influenced by personal taste, and each piece of calligraphy is an exciting new design challenge. The layout should be appropriate to the words, and the size, style, weight and colour of the writing all contribute to creating the right atmosphere.

Guidelines for layout:

The following guidelines are for simple layouts of a single text. Once the text is written the following elements must be considered:

Writing line length For poetry retain the line breaks if possible; for prose about nine words to the line is suitable for a horizontal layout and about five for a vertical one.

Interline spacing The choice of line spacing affects the overall shape and texture of the text area. Increased line spacing lengthens the text area, and closer line-spacing shortens it. Long lines generally require more interline space than short lines. The line spacing chosen depends on several factors – style, weight, size of writing, length, number and arrangement of lines – and must be assessed for each piece of calligraphy.

Shape of text area This is affected by interline spacing and length, number and placement of lines. For poetry the natural line breaks will affect the shape of the text area, and for prose you can select your own line breaks and choose a vertical or horizontal text area. The mood of the text may also influence choice of text shape.

Margins The space between and around text areas is an important consideration in layout,

the margins being crucial to the design. Inadequate margins make the work look crowded and appear to burst out of the page. Adequate margins help the design hold together.

Assessing margins Once a paste-up is complete assess the margins by placing four strips of coloured card round the text, moving them in and out to consider the margins and rule them in pencil.

Vertical layouts Where the text area is vertical the margins in figure 1 are appropriate. Decide the top margin, then the bottom margin, which is approximately twice the top margin, stressing the vertical format. The side margins are in between the two.

Horizontal layouts For these the top margin is also established first. The side margins are approximately twice this, stressing the lateral format, and the bottom margin is slightly more than the top to prevent the lettering appearing to fall out of the page (figure 2). On less formal layouts unconventional margins can be very effective. Figure 3 suggests a layout for text about land and sky, and figure 4 a layout for a Japanese Haiku poem. You can be as imaginative with use of space as you can with letterform.

Aligned left (vertical or horizontal) See figures 5, 6, 7, 8. This is widely used and is suitable for a first piece of calligraphy. With poetry, the right edge is determined by the natural line endings; with prose choose line breaks so that the right edge of the text area is aligned vertically.

Alternate lines (vertical or horizontal) See figures 9, 10. This is used for poetry, and entails two left-hand margins, alternate lines are inset to the second margin. The first line is generally aligned to the first margin to give a strong top left corner to the design.

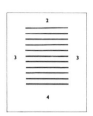

1. Margins for a vertical layout.

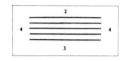

2. Margins for a horizontal layout.

3. Unconventional margins.

4. Unconventional margins.

5. Aligned left margin, justified

6. Aligned left margin, unaligned right edge, vertical layout.

7. Aligned left margin, justified

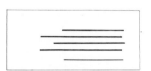

8. Aligned to left, unaligned right, horizontal layout.

9. Alternate lines inset, unaligned right edge, vertical layout.

10. Alternate lines inset, unaligned right edge, horizontal layout.

11. Justified right, vertical layout.

12. Aligned right, horizontal layout.

13. Centred, vertical layout.

14. Centred, horizontal layout.

15. Asymmetrical, vertical layout.

16. Asymmetrical, horizontal.

17. Title at the top, credit underneath, vertical centred layout.

18. Title and credit underneath the text, centred vertical layout.

19. Title and credit amongst text, asymmetrical horizontal layout.

20. Title and credit with wide letter spacing, centred vertical layout.

21. Two-column layout, vertically offset.

Aligned right (vertical or horizontal) See figures 11, 12. All the lines in this layout start in different positions on the left-hand side to give a free left edge and are aligned to a right margin.

Centred (vertical or horizontal) See figures 13, 14. This is very useful for poetry where long and short lines have to be accommodated. A central vertical line is ruled in pencil on the background layout sheet to help centre the text during paste-up.

Asymmetrical layouts (vertical or horizontal) See figures 15, 16. These give wide scope and are suitable for creating movement in the text. Line beginnings move in and out, by different amounts, depending on the line length. Avoid blocking line endings vertically as this gives a static look. Overlap lines down the central core of the text area to give a strong design.

22. More complex layout incorporating different weights and sizes of text and illustration, vertical layout.

23. More complex layout with different weights and sizes of text, horizontal layout.

Placing of title and credit (author's name and other details) These are an integral part of the design. In simple layouts the title is usually above the main text and the credit below, or title and credit will be written small below the main text. (figures 17, 18). They can also be placed in spaces left within the text (figure 19). If the title is at the top it tends to be made dominant. Try it first with normal spacing and then wider spacing, especially if it is a short title and you need to lengthen it (figure 20). Consider also if you want the title formal or lively.

Title and credit offer good design opportunities for contrast of size, letter weight, style, letter spacing and colour within the layout. Figures 21, 22 and 23 show titles and credits on more complex layouts.

Steps in making a layout

1. Read the words. Make thumbnail sketches of initial ideas.
2. Make writing trials of different scripts, weights and sizes in black ink on layout paper. Write all the text (except title and credit) in one nib size.
3. Cut up the lines of writing and arrange in possible layouts on a background sheet of layout paper.
4. When a satisfactory layout has been found, paste up.

There are many other layout possibilities, including writing in a circle or spiral, writing round the sides of a square – placing a block of text, a decorative word or alphabet or an illustration in the middle, and writing on curved lines. Layout is a very creative area of calligraphic design – start simply, gradually trying more challenging layouts as you progress.

Analysing an historical script

An analysis of historical letterforms gives an excellent basis for adapting them to contemporary use, and provides a method that can be applied to understanding any script, historical or modern. Enlarged reproductions of historical scripts are available in contemporary calligraphy books. Fine roundhands dating from the 9th and 10th centuries and Renaissance Italics make a good starting-point for such a study.

The first step is to make some general observations about the script: its date, style, letterform characteristics and spacing. Then follows detailed analysis. The analytical method on pages 10–11 is applied in the following study.

Analysing a Renaissance Italic

This 16th-century Italic is printed from wood-blocks. It is formal, and has vertical stress due to compression of letterforms and long ascenders/descenders. The letters are mostly unjoined. Line spacing is generous to allow clearance of ascenders/descenders.

Pen angle This should be found before deducing letter weight. Draw pencil lines in the direction of the nib edge (figure 1) on various letters, e.g. beginnings and endings of 'l', 'n', tops of 'c', 'e', 'o'. Draw a horizontal line below each of them and measure the angle with a protractor (as shown in figure 2). This is the pen angle used for the script. There may be slight variation of angle from letter to letter. The pen angle for the script is the average of all the angles you have measured. In this example, the angles measured range between 38° and 48° with no deliberate change of pen angle for any letters. The average pen angle is 43°.

Letter weight: The x-height is measured in nib widths. The thickest strokes are at right

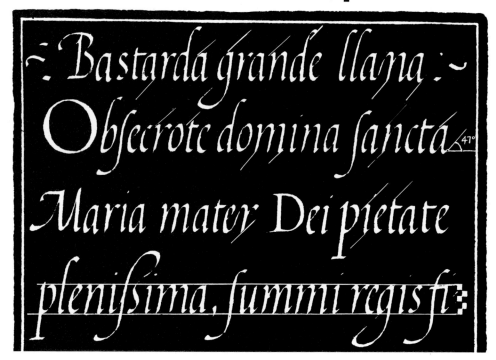

1. Renaissance Italic form, 'Arte de Escrivir' by Francisco Lucas, Madrid, sixteenth century. **(33% larger than original)** Victoria and Albert Museum. Marked up top show pen angles and letter weight in nibwidths.

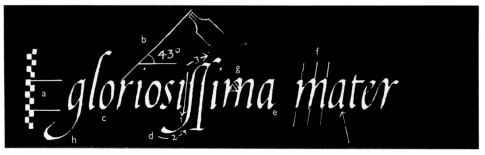

2. Letter analysis, showing: a) x-height, b) pen angle, c) 'o' form, d) example of stroke number, order and direction for long 's', e) oval serifs, f) forward slope, g) asymmetrical arch shape, h) ascenders and descenders.

3. Missing and alternative letters.

abcdefgbhijkklmnopqrstuvwxyyyz

4. Contemporary Italic alphabet derived from the historical example.

5. Using the script.

Renaissance Italic

angles to the pen angle and are the width of the nib. From the historical example find one of these strokes. Place dry nibs against it to find a nib the same width, e.g. on an 's' diagonal. Rule lines on the example to contain letter bodies of one line of writing, ink up with chosen nib size and mark the x-height in nibwidths (figure 1). Draw lines on layout paper at the x-height, 5 nibwidths of a Rexel 2½ nib. Copy one letter to check that the thickness of strokes looks the same.

The 'o' form The 'o's are compressed ovals. The first 'o' in figure 2 is a good model because it is very smooth on both sides, and the shape of both sides is well related. The letter looks the same upside-down as the right way up: this is a good check of 'o' form.

Number, order and direction of strokes See 'Italic', page 52. The direction and number of strokes depends on the script and the particular letter. This is a flowing script

with few pen lifts, making springing arch forms in one continuous stroke.

Speed of writing Indicators of writing speed are slope, serif type and arch structure. This script has a forward slope, final foot serifs are slightly drawn out, and the arches springing, suggesting speed.

Serifs Most of the serifs used at stroke beginnings and endings are oval, relating to the 'o'. The serifs at the base of 'p' are formal slab serifs.

Letter slope Rule lines down stems of several letters to find the slope. This may vary slightly, but deduce the dominant slope. The angle between these sloping lines and the vertical gives the slope, which is 8° for this script.

Arch shape and structure The arches are asymmetrical and leave the letter body about ⅔ the way up the x-height in a curve. The springing arch is reflected in 'b h k m n p r' and in the joins of 'u, oval y, a d g q'.

Ascenders and descenders Ascenders are 4 nibwidths and descenders 4–5 nibwidths. They terminate in an elegant curve.

Letter, word and line spacing Letter spacing is even, the space between straight-sided letters being approximately the width of an 'n' between words. Interline spacing is two x-heights.

Follow-up practical work

Copy the alphabet letter by letter before making modifications and designing missing letters, e.g. 'w' and 'k'.

To copy: Rule up double lines on layout

paper in pencil at 5 nibwidths x-height of the same size nib (Rexel 2½). Refer to several 'a's, find the best example, and copy, using a 43° pen angle. When copying letters, check details such as slope, letter width, springing point of arches and join level of body to downstroke on right side, serif size and shape against the historical example. Follow this process for the rest of the alphabet. Compare letters of similar formation to ensure they relate, such as 'a d g q' and 'c e o' and 'm n'.

Modifications Adapt any features you consider archaic or which need changing to improve the legibility or relatedness of the script, e.g. omitting the long 's' and narrowing the 'h' which is wider than other letters.

Missing letters Design missing letters, using those available as reference, e.g. for 'j' refer to 'f', for 'q' follow 'g' with a descender ending like 'p', 'w' is based on 'v', 'y' can be based on 'u' or 'v'.

Practice Write a complete alphabet several times, then trace or copy a line from the historical example for rhythm and spacing. Practise words with straight-sided letters as these are easier to space. Use the script in a short quotation, using the same line spacing as the historical example, and then try a smaller nib size. The original manuscript was written with a quill approximately the equivalent of a Rexel number 2½ nib. This is an ideal script to study when beginning Italic: it is so regularly spaced and the letterforms are beautifully proportioned and accurately written.

Useful processes

Preparing a paste-up layout, including artwork for print

Whether you are designing a piece of calligraphy or preparing a design for print, you have to go through several stages in the design process: make roughs, test lettering sizes, weights, styles, colours and layouts, working towards a final paste-up. This leads either to a finished piece of calligraphy, or to a paste-up artwork, for the printer.

Preparation Read wording, and make a small pencil sketch of layout ideas. Try different nib sizes and make a selection. If preparing artwork for print you can work larger than the printed final item (see figure I). This is especially helpful if the final item is small, but you must work to the same proportions as the final item. For example, if the final printed item is A5 size 210 × 148mm, (8 ¼ × 5 ⅞in) you could prepare artwork at A4 size 297 × 210mm, (11 ¹¹⁄₁₆ × 8 ¼in). You do not have to work exactly to 'A' sizes. When artwork is photographically reduced for print it sharpens the lettering; if it is increased it tends to blur stroke edges.

Rule up x-heights accurately on layout paper and write out the text.

Arranging text. Cut the text into lines and arrange on a white background sheet; it is difficult to judge line spacing and margins if the background sheet is a colour. The background sheet can be layout paper if it is a paste-up reference for a piece of calligraphy, or white card if you are preparing paste-up artwork for print. Leave plenty of surrounding space for assessing margins later.

Move writing around to try different layouts; also try different interline spacing intervals to see the effect.

Pasting up When the layout is satisfactory,

paste up, putting down enough gum for one line of writing at a time. Before pasting up draw one horizontal line about 7.5cm (3in) down from the top of the paper to ensure that the first line pasted up is absolutely square to the edges of the background sheet.

Place the first line of writing on the ruled line. Put the gum down for the second line and paste up. Check interline spacing between the two rows of writing by marking the measurement on a straight edge of a paper strip (figure I page 12), and check interline gap at the beginning and end of the line, sliding the line of writing up or down to adjust if necessary.

Proceed until all the lines of writing are pasted-up, checking each line is square to the background left edge with a set-square.

Centred layouts To paste up a centred layout, draw a vertical line in pencil down the middle of the background sheet. Fold each line of writing in half, placing the fold on the ruled centre line as you paste up. Some people prefer to rule up the background sheet before pasting up, but this is not necessary if you follow the method above.

Assess surrounding margins (see page 16) by placing coloured paper or card strips round the work and ruling margins in pencil.

Final stage of artwork for calligraphy: Unless the finished piece is black and white you will need to prepare a colour rough. Make writing trials on layout paper to decide colour scheme. Write out text again in colour, cut and paste the colour rough as previously described for black and white.

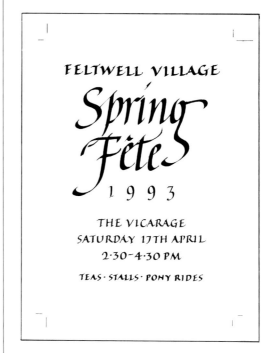

I. Working up in scale: Draw a rectangle to the required size (abcd) and create a diagonal line from (c) through (b) to a point (e) which should be just beyond the size you want to work to. Any rectangle that shares this diagonal will have the same proportions.

2a. Final paste-up showing trim marks for printing.

Select a paper by trying various papers with a line of writing in colour, rule up and write the final piece of calligraphy.

Final stage of artwork for print: Any guidelines you draw that are not to be printed should be drawn in very light pencil or light blue pen or pencil. The printer's camera will not detect lines drawn this way. At the four corners of the design area you should draw trim marks about 3mm (⅛in) outside it. These must be drawn in black as they need to print as a trimming guide for the printer. You will then need to write instructions on an overlay (figure 2b), indicating any reduction required to achieve

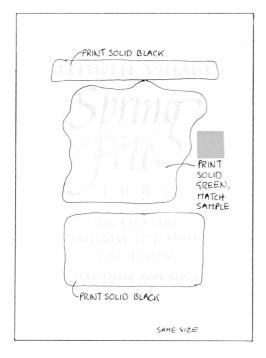

2b. Overlay with instructions to printer and a colour sample for printer to match.

final size, and instructions about colours.

Colour guides If you require more than one colour all artwork can remain on one paste-up sheet, as long as the writing to be printed in different colours does not touch or overlap. Simply ring round each area of writing on the overlay and state required colour (figure 2b), providing a colour guide, either giving the reference number from the printer's colour guides, or attaching a small colour sample.

Printing processes

Photocopying This is the cheapest print method. You can copy onto coloured paper,

FELTWELL VILLAGE

Spring Fête

1 9 9 3

THE VICARAGE
SATURDAY 17TH APRIL
2·30–4·30 PM

TEAS · STALLS · PONY RIDES

2c. Two-colour poster printed.

if required, as long as it is thin enough for the machine, or your artwork can be colour copied. Ensure that no cut and paste lines show when photocopied. If they do you can white out any lines on a black and white master photocopy, with liquid paper, white gouache or process white and print from that. Alternatively, you can get a PMT made (photomechanical transfer) which is a special photograph of the artwork available from printers, and use this as a master from which to photocopy or print. Remember to get a photocopy or PMT reduction if your artwork is larger than you want the final item.

Offset-litho. Commercial printing uses this process most frequently, and it is the usual process for reproduction of calligraphy. A full-colour image can be printed through colour separation during the printing process, but calligraphic artwork for print does not usually require full-colour.

Printing more than one colour from calligraphic artwork may mean presenting some of the artwork on an overlay as detailed above. Tints of any colour can also be printed, if you want any part paler. A 90% tint would still be quite dark, whereas a 10% tint would be very pale. By offset litho or silk-screen printing, you can also print 'reversed out' lettering, i.e. lettering that appears white, or the colour of the chosen printing paper, with an overprinted background colour of your choice, from your usual black and white artwork.

Silk-screen printing This is a more expensive process. It is mainly used for short runs and for especially large items. An important aspect of silk-screen printing is that it can print on a wide variety of surfaces, e.g. plastic, perspex, glass, wood, metal, fabric and thick card.

Writing over backgrounds

Well-written and designed calligraphy should be able to stand alone when required. However, writing over coloured and textured backgrounds offers a whole range of interesting possibilities. Many of these background techniques are very straightforward and no previous art training is necessary.

For watercolour washes use a heavy weight (300 gsm) paper. This should not cockle when the wash is applied and so you will not need to stretch the paper. Most artists use watercolour paper, which has a slightly textured surface, for washes. This can be used, though it is slightly more difficult to write on than a hot-pressed paper. However, the smoother surface of the hot-pressed paper does not give such interesting wash effects. Try both surfaces. You need artist's quality tube watercolours for best results. Some pigments stain evenly, while some, which are insoluble, give a more textured effect to the wash. The subtleties of mixing washes is a subject in itself, and books on painting techniques will give further details. It is useful to have a large round wash brush and a flat brush 2.5–3cm (1–1½ in) wide.

Useful techniques

One-colour watercolour wash To apply the wash, work on a surface very slightly sloping down towards you; squeeze about 1cm (½ in) of watercolour into the palette and dilute with water mixing well. Using a large wash brush apply the wash in horizontal strokes back and forth across the page, one band touching the next band – if this is correctly applied the wash should blend in as it dries without a striped effect. Gently remove the surplus bead of watercolour at the bottom of the wash with a dry brush or tissue, and leave flat to dry for several hours.

Graded watercolour wash Apply as above, but this time have a number of washes of one colour but different strengths mixed in different palettes. Start the wash with the strongest mix at the top, continuing for a few bands back and forth, then dip into the next strongest mix and repeat the process until you finish with the most diluted wash.

Mixed colour wash Mix the colour wash in different palettes. The wash can be applied as above in bands, progressing from one colour to the next every few bands, or the different colours can be applied at random over the page, with a circular free motion. When all the required areas have been covered you can tilt the paper in different directions to blend the colour. Additional colour can be added if necessary while the wash is still wet and mobile.

Another method is to put clean water over the required wash area with a large wash brush, then brush on the colours lightly at random and blend as above. A flat brush can give very lively patterned effects with a wash, when used freely.

Sponging Interesting background textures can be applied on their own or over any number of the above washes by dipping a piece of sponge into any number of mixed watercolours or gouache and dabbing on. You can also make a striped background with a whole sponge or a strip cut from it.

Chalk pastel background: This can be a single colour or a mixture and applied directly with the pastel or a small amount can be scraped into powder and rubbed into the paper with cotton wool, tissue or fingers. You can either make a dense background or a light one. The dense layer is more difficult to write over, but spraying with fixative and dusting with gum sandarac helps.

Rolled The roller can be sponge or a lino-printing roller. Squeeze gouache onto a piece of glass or clear plastic and run the roller over it to spread it out; ensure the roller is entirely covered then roll onto paper. You can roll back and forth over the same area to give a denser coverage if required. You can roll a second colour, with a separate roller, or you can mix colours on the glass in the first place. When the background is dry dust with gum sandarac to give sharp writing.

Card strip Mix watercolour or gouache and dip the end of a short strip of thick card into the paint and apply in straight or curved sweeps to the paper. You can use different widths of card. The fact that the paint runs out can enhance the texture. This method can be used on coloured paper or over a background made in one of the above ways.

Spatter A fine spray of dots can make an interesting background texture. Mix one or more colours of gouache or watercolour in separate palettes, dip an old toothbrush in and hold it about 15cm (6in) from the paper surface; draw the bristles back with a finger to spatter. If it is too near the paper, the spatter will not be fine enough. Alternatively, you can use a simple spray diffuser, putting one end in a deep well of thin paint and blowing through the diffuser. A spatter background can be put over any of the other backgrounds described. Spatter with gold or silver can look very effective, especially on a dark background.

Facing page Poem written in ink over watercolour wash, metal pens, Fabriano 5 paper 46 x 31cm (18 x 12in).

Following page Various background techniques using watercolour written over with gouache in the pen. 1. Sponging. 2. Flat Wash. 3. Chalk pastel. 4. Spatter. 5. Graded wash. 6. Card Strip. 7. Mixed wash. 8. Rollered.

The wind sings through the trees
making patterns of green
dancing against the clear blue sky

PALE SUNLIGHT FALLS ON SEA·ETCHED ROCKS
HEAPED IN STRANGE SCULPTURES OF BLUES & GREYS
STRETCHING INTO THE DISTANCE

Breaking waves, glass·like tongues of sea
racing up the silken sand
Deserted shore, seabirds stand motionless
on a distant misty isle

MOSSES &
LICHENS
COVERING
THE ROCKS

1

waving
grasses

2

3

dragonflies
DARTING OVER
THE STILL RIVER

STAR
FILLED
NIGHT
SKIES

4

Larks,
ascending
in the
morning
sky

5

MOVEMENT
MOVEMENT

6

wild
meadow
flowers

7

8

The
darting
rain

Resist technique

Art masking fluid is an agent which allows you to mask out areas with a brush, or mask out letters with a pen. A wash of water-colour, gouache or coloured inks is applied and when it is dry the masking fluid is removed to reveal white lettering (or lettering of the paper colour used), reversed out of a coloured wash background.

This method is very effective and relatively easy. It is important to get sharp letter strokes. Try writing only a word or two initially, to practise this. The masking fluid is white or yellow and rather difficult to see, so you will need good lighting, as for all calligraphy, from an adjustable reading lamp.

Using masking fluid

Shake the bottle of masking fluid well before use and pour out a small amount into a small china palette. Use a loose reservoir to allow the masking fluid to flow adequately. Dip the nib straight into the masking fluid (it ruins brushes) shake off surplus and wipe away any masking fluid from the front of the nib. Write on a sloping board to control the flow and use hot pressed paper of approximately 300 gsm, as the masking fluid will pull up the paper surface when removed if it is soft, and a heavy-weight paper will prevent you having to stretch the paper for the wash. After writing a word or two, add a few drops of water if the masking fluid will not flow easily. As you write, remove any cobweb-like strings of masking fluid from the nib from time to time or this will prevent sharp lettering. Put the board flat while the masking fluid dries. When dry (approximately 10 minutes) apply the watercolour wash over the masking fluid lettering. Ensure the wash entirely covers all the lettering or it will not show when the masking fluid is rubbed off.

Make sure too that the wash is strong enough in colour for the lettering (which will be white) to show up with enough contrast. Place the wash on a flat board until it is dry enough to remove the masking fluid – about three hours. This can be done with an eraser or your finger to reveal the white writing. You can use this technique on coloured paper in the same way, in which case the lettering will be the colour of the paper when the masking fluid is removed.

Problems and solutions

1. The writing is blobby: the masking fluid is too thick, so dilute further; or the board is too flat to control the flow, so steepen board angle; or the pen is overfilled, so shake surplus out after filling and wipe the front of the nib; or the strokes are not finished with a fine serif to give sharp endings; or threads of masking fluid form on the nib and spoil stroke sharpness – check nib frequently and pull threads off.
2. Lettering does not show up well enough after the masking fluid is removed: either the wash is not strong enough, or the masking fluid is too dilute; only dilute the masking fluid if it will not flow easily through the nib.
3. Masking fluid pulls up paper surface when removed – the paper is too soft.

In spite of any technical hitches which may occur, this technique is worth persevering with and once you have managed to achieve sharp lettering with this medium many interesting possibilities are available to you.

You can make an effective greetings card with masking fluid, with interesting edges to the wash by:
1. Cutting the paper to required card size.
2. Cutting 2 strips of low-tack masking tape, tearing lengthwise down the middle and sticking them down, ragged edge inwards round the front of the card or round the entire card. 3. Write wording in masking fluid allow to dry. 4. Put on the colour wash, brushing right up to the edges of the masking tape and allow wash to dry. 5. Remove masking tape and masking fluid, to reveal white lettering and interesting edges to the wash, created by the torn edges of the tape.

1. *Above* This shows a watercolour wash over masking fluid lettering written freely using a ruling pen. The masking fluid has been removed from A, B, C and D only.

2. *Following pages* Resist using masking fluid, metal pens watercolour wash Fabriano 5 paper 305 x 76mm (12 x 3in).

Alphabet
rhythmical
capitals
lettering
cursive
handwriting
script

formal
writing
calligraphy
history
manuscript
flowing
letterform
design

A B C D E F G H I J K L M N O

ALPH

Alpha

Abcdefg hijklmn opqrs

ABET

PQRSTU VWXYZ

abcdefghijklmnopqrs

ABCDEFGHIJKLMNOPQR

VWXYZ

The versatility of the letterform

Exploring textures

A sound approach to calligraphy involves learning the alphabets in the basic repertoire at their 'normal' x-height first - this letter height being derived from historical examples. Each of these styles of writing makes a different lateral texture along the writing line. Italic gives a compressed line of text which is reasonably dense, whereas Foundational hand, being a more rounded and widely spaced script, gives a more open texture along the line. Likewise Italic capitals, being compressed, will give a denser lateral pattern than the more open Roman capitals. In addition to these different lateral textures, there are many possibilities with vertical texture, through using different line spacing. This can be wide, medium or close, or with lines of text touching, particularly with capitals as there are no ascenders and descenders.

Once you are competent with the normal weight lettering with these scripts and have tried different line spacing patterns there are many exciting possibilities when you experiment with letter proportion, and letter and line spacing further.

The main factors you can vary are:
1. Letter weight.
2. Letter width.
3. Letter slope.
4. Letter spacing.
5. Line spacing.

Letter weight This can be varied (a) by keeping the x-height the same and using different nib sizes; a thin nib at the same letter height gives a lightweight letter and a wide nib gives a heavy-weight, bold letter (figure 1); and (b) by using the same nib size and changing the x-height. The small x-height

1. Changing the letter weight by using different thicknesses of nib at the same x-height.

writing writing writing

2. Changing letter weight by using the same nib at different x-heights.

writing writing writing Writing

3. Changing the letter width and letter spacing to match.
a. (Italic)
b. (Capitals)

a *writing writing*
writing writing writing writing

b *WRITING WRITING*
WRITING WRITING WRITING

4. Letter slope:
a. Slightly sloping sharpened Italic.
b. More sloping sharpened Italic.

a *writing* b *writing*

creates heavy-weight letters and a tall x-height creates lightweight ones (figure 2).
Letter width This can be varied by expanding or compressing the letters and letter spacing to match, to give a narrow dense texture or a wide spacious texture (figures 3a, b).
Letter slope The slope of the letters affects the texture and the writing line. A compressed Italic with a steep forward slope will give a busier-looking texture than a more upright version; similarly with compressed capitals (figures 4a, b).

Letter spacing It is essential to space letters accurately before you experiment with spacing. The general principle is that the spacing pattern goes hand in hand with the particular alphabet – a narrow alphabet will require narrow letter spacing and a wide alphabet wide spacing. An alphabet comprised of a mixture of narrow and wide letters, such as Roman capitals will have a spacing pattern that accommodates this. Letter spacing can be closer or wider than the norm for a particular alphabet if the design requires it (figures 5a, b). For

a

writing

b

WRITING

writing

WRITING

writing

W R I T I N G

W R I T I N G

5. Different letter-spacing patterns using the same letter proportions:
a. Italic. b. Roman capitals.

a *writing* b *writing*

writing *writing*

6. Line spacing (compressed sharpened cursive italic).
a. Close line spacing, one x-height.
b. Wider line spacing, two x-heights.

a WRITING b WRITING

WRITING WRITING

7. Line spacing (Italic capitals)
a. Close line spacing, half a letter height.
b. Wider line spacing, one letter height.

WRITING WRITING

WRITING WRITING

WRITING WRITING

8. Alternating different styles, weights and textures.

example, wide letter spacing is often useful and attractive with Roman capitals, for headings and credits on a panel of calligraphy; or if you want to use Roman capitals in a texture with close line spacing, a closer letter spacing may help the overall texture. Letter widths and spacing variations may also arise out of experimenting – an important part of calligraphy.

Line spacing This can be narrow, to give a close-knit vertical texture, intermediate, or wide, to give an open vertical texture. The overall texture of an area of writing depends very much on the texture of the line of writing as well as the line spacing. It is a very useful exercise to photocopy and cut and paste lines of writing in a series of vertical and lateral blocks with different line spacings, to see the effect of the line spacing on vertical texture. This can be repeated for a number of scripts written at different heights, nib sizes, and letter widths (i.e. a compressed or expanded alphabet) comparing all these textures. Some interesting design ideas for creating different textures should emerge from such an exercise (figures 6a, b, 7a, b).

For further textural effects, you can of course alternate different styles, weights and sizes, e.g. writing a poem in a foreign language, and its translation on alternate lines: figure 8, suggests this effect. These are just a few examples from a wide range of possibilities. Figures 9, 10, 11 show some other ideas.

9.

9 –11 Experimenting with different writing textures,
9. using an automatic pen,
10–11. using a line ruling pen.

10.

11.

ALPHABETS

Using the alphabets

A detailed breakdown of the letterforms, stroke-by-stroke, is provided on two facing pages for each alphabet. In the columns to the left and right of each alphabet, you will find the following essential information:
- skeleton letters
- characteristics key – the characteristics of the edged-pen letters of each alphabet, such as letter weight, pen angle, (o) form, stroke order and direction, arch structure, letter slope and spacing
- construction key – detailed points to note in letter construction of each particular alphabet

Scripts

The name of the calligraphic script is given – and demonstrated. General information about the script, its main characteristics and a brief history is provided.

Skeleton letters

These show the essential basic form stripped of weight and personal mannerisms. They are a sound starting point from which to develop the weighted version of each alphabet. The skeleton letters are shown in related formation groups where appropriate.

Main letterforms

The letters are shown in alphabetical order, broken down into their component strokes, with stroke order, number and direction shown by arrows in red. This information is helpful when you are first learning the alphabet and for seeing stroke joins clearly.

The construction lines are double lines ruled in red to indicate letter body height for each alphabet. (See *Characteristics* key to find the specific letter body height in nibwidths for each script.) All alphabets demonstrated stroke-by-stroke are written with a Rexel no 1½ nib.

Where space allows, alternative letterforms are shown and, for some alphabets, awkward letter joins also.

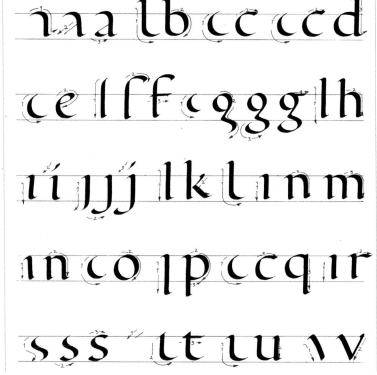

Foundational hand

Foundational hand, based on the circle and vertical straight line, makes an excellent introduction to calligraphy. It was formulated at the beginning of the 20th century by Edward Johnston, who revived the craft of edged penmanship. He based the Foundational hand on a 10th-century round script from the *Ramsay Psalter*, now in the British Library. It is a very legible script and a fine example of strong, vital calligraphy. Foundational hand is ideal for learning about related letterform and is an excellent formal script for contemporary use.

Skeleton letters

Group **1** (i) and clockwise arches. Group **2** circular letters. Group **3** diagonal letters. Group **4** (f j s) with related curves. Group **5** anti-clockwise arches.

36

32

Characteristics key

When learning or analysing any alphabet, it is essential to know the characteristics of the script. The height of the letter body, measured in nibwidths, must be correct for each script. So, too, must the pen angle which affects the distribution of weight round the letterforms. It is necessary to recognize the (o) shape, which is usually reflected in the curved parts of other letters and is, therefore, a key letter in any script. The letter strokes must be written in the correct order and direction to obtain the flow of the script and good spacing. Arch shape and structure varies from script to script and must be recognized for each one. Other characteristics, such as letter slope, serif type, height and length of ascenders and descenders, are all specific to each script shown and must be followed.

The **bold** figures in the characteristics key explain the correspondingly numbered letterform details in the figure above.

Spacing

The figure demonstrates the placing of two adjacent straight-sided letters, usually (n) and (i); this sets the area between all letters of the script written at a given nib size and letter height. It also shows the placing of curved letters next to straight letters and of two adjacent curved letters; these are placed slightly closer to create the same inter-letter area. The figure usually also shows an additional word for further demonstration of the spacing pattern. (See pages 14-15 for further explanation of the principles of letter spacing.)

Construction points key

Although it may be relatively easy to capture the basic character of a script, there are many fine details and refinements necessary. The **bold** letters in this key correspond with the same letter of the alphabet to point out some of these construction details.

Occasionally more than one step in the stroke-by-stroke construction sequence is shown on a single letter for economy of space, where this sequence has been fully shown on a previous, similarly formed letter.

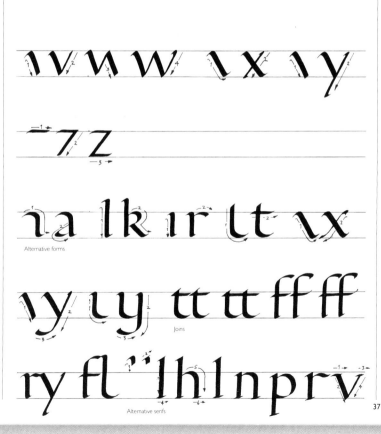

Characteristics key

1 Letter weight (x-height 4½ nibwidths). **2** Pen angle 30° (45° for thick strokes of (v w x y), 30° for (z), top and bottom, 0° for (z) diagonal stroke). **3** (o) form circular. **4** Number, order and direction of strokes per letter. **5** Level of arch joins. **6** Circular serifs. **7** Height and length of ascenders and descenders (approximately 2½ to 3 nibwidths). **8** Upright alphabet. **9** Circular arches.

Spacing

Create an equal area between letters, the (ni) distance – virtually the width of the (n) counter – sets this area.

Construction points key

a Relate curves to circle, align letter vertically on left. **b** Note level at which base curve starts. **c** Align vertically on right, overlap strokes for strong join **d** Relate to (c). **e** Top joins above half-way. **f** Top of cross bar on the line. Small circular serifs. **j** Smooth join. **k** Diagonals at right angles. **l** Relate to (b). **m** Halves equal width, arches circular. **n** Relate to (h m). **o** Circular form, smooth curves **p** Relate to (b) and area of counter to (b d q). **q** Relate shape to (d). **r** Relate branch to arc of circle. **s** Align vertically on right, counters circular, bottom one slightly larger. **t** Relate to (b l u). Top of cross bar on the line. **u** Relate base to (n) arch. **v w x y** Steepen pen angle to 45° for thick strokes, keep letters upright. **z** Flatten pen angle to 0° for diagonal, align letter vertically front and back.

Alternative forms

Joins

Alternative serifs

37

foundational hand

abcdefghi

jklmnopqr

stuvwxyz

Foundational hand

Foundational hand, based on the circle and vertical straight line, makes an excellent introduction to calligraphy. It was formulated at the beginning of the 20th century by Edward Johnston, who revived the craft of edged penmanship. He based the Foundational hand on a 10th-century round script from the *Ramsay Psalter*, now in the British Library. It is a very legible script and a fine example of strong, vital calligraphy. Foundational hand is ideal for learning about related letterform and is an excellent formal script for contemporary use.

Skeleton letters

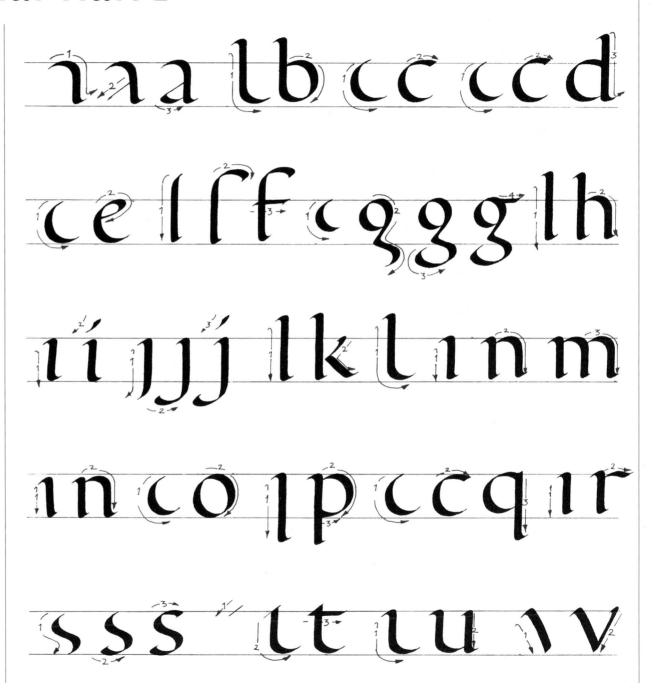

Group **1** (i) and clockwise arches. Group **2** circular letters. Group **3** diagonal letters. Group **4** (f j s) with related curves. Group **5** anti-clockwise arches.

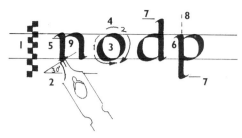

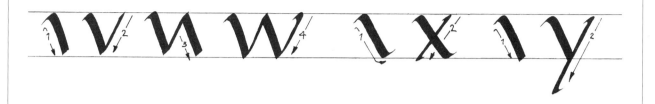

Alternative forms

Joins

Alternative serifs

Characteristics key

1 Letter weight (x-height 4½ nibwidths). **2** Pen angle 30° (45° for thick strokes of (v w x y), 30° for (z), top and bottom, 0° for (z) diagonal stroke). **3** (o) form circular. **4** Number, order and direction of strokes per letter. **5** Level of arch joins. **6** Circular serifs. **7** Height and length of ascenders and descenders (approximately 2½ to 3 nibwidths). **8** Upright alphabet. **9** Circular arches.

Spacing

Create an equal area between letters, the (ni) distance – virtually the width of the (n) counter – sets this area.

Construction points key

a Relate curves to circle, align letter vertically on left. **b** Note level at which base curve starts. **c** Align vertically on right, overlap strokes for strong join. **d** Relate to (c). **e** Top joins above half-way. **f** Top of cross bar on the line. Small circular serifs. **j** Smooth join. **k** Diagonals at right angles. **l** Relate to (b). **m** Halves equal width, arches circular. **n** Relate to (h m). **o** Circular form, smooth curves. **p** Relate to (b) and area of counter to (b d q). **q** Relate shape to (d). **r** Relate branch to arc of circle. **s** Align vertically on right, counters circular, bottom one slightly larger. **t** Relate to (b l u). Top of cross bar on the line. **u** Relate base to (n) arch. **v**, **w**, **x**, **y** Steepen pen angle to 45° for thick strokes, keep letters upright. **z** Flatten pen angle to 0° for diagonal, align letter vertically front and back.

Foundational hand in use

Foundational hand, based on the circle and vertical straight line, is a popular learning script for beginners in calligraphy. However, it can also be very useful and attractive in a wide variety of contexts. It lends itself primarily to formal designs but, written with rhythm, can be quite a flowing script suitable for use in less formal presentations of prose and poetry.

1 Foundational; hand, used with a centred layout, to convey the quiet, mellow atmosphere of Venice. *(Gaynor Goffe)*
2 Illustration and Foundational hand combined in a short quotation suitable for a greetings card. *(Gaynor Goffe)*
3 Combining different sizes of Foundational hand in a centred vertical layout. *(Gaynor Goffe)*

VENICE

Water and marble and that silentness
Which is not broken by a wheel or hoof;
A city like a water-lily, less
Seen than reflected, palace wall and roof,
In the unfruitful waters motionless,
Without one living grass's green reproof,
A city without joy or weariness,
Itself beholding, from itself aloof.

ARTHUR SYMONS

1

Stems of
frozen reeds,
still sentinels
of bleak
December fields.
Bare hedgerows and
landscape,
dark furrowed earth
frost-blanketed.
Subdued winter palette
as the year
draws to a close

3

Like these cool lilies
 may our loves remain,
Perfect and pure
 and know not any stain.

ANDREW LANG

2

ROMAN CAPITALS

ABCDEFGHI

JKLMNOPQR

STUVWXYZ

Roman capitals

Our Western alphabet dates back to the appearance of the Roman alphabet over 2,000 years ago. The capitals used in ancient Rome for carved stone inscriptions give us the letterforms which are the foundation of the modern day calligrapher's Roman capitals. With their elegant proportions based on the circle, square and triangle, Roman capitals allow an excellent understanding of the concept of letter proportion and related form. It is important to note relative letter widths from the skeleton letters diagram.

Skeleton letters

OQCGD
HAVNTU
XYZ IJK
BPRSEFL
MW

All curves relate to the circle
Group **1** circular letters – (C G D) are ⅞ width of a square containing the circle. Group **2** three-quarters width rectangular letters. Group **3** (I J) and narrow half-width letters. Group **4** wide letters – (M) is square, (W) equals two (V's).

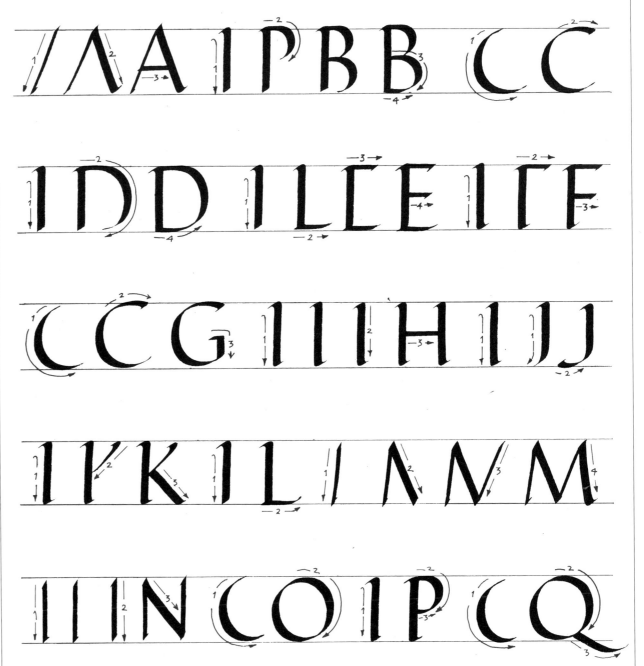

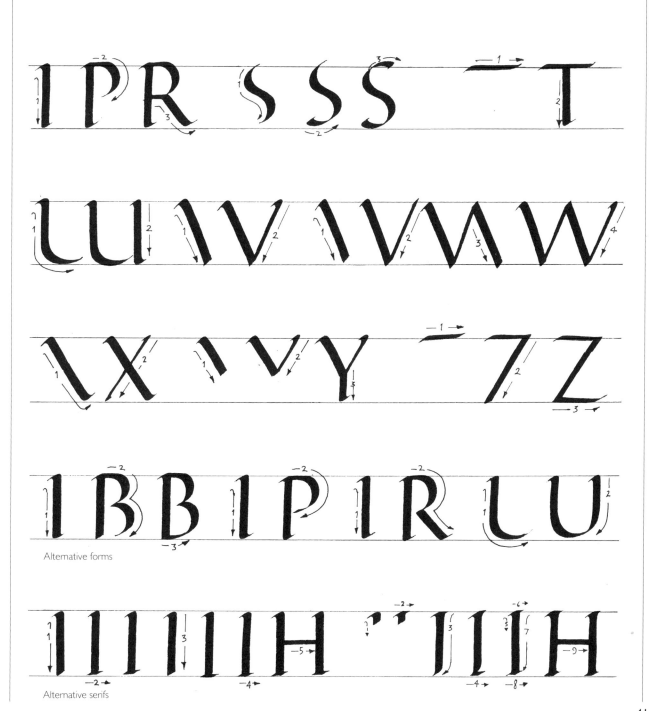

Alternative forms

Alternative serifs

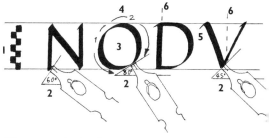

Characteristics key

1 Letter weight (X-height 7 nibwidths). **2** Pen angle 30° most letters, 45° for (A V W X Y), 50° to 60° for first stroke of (M) and uprights of (N) 45° for others, 0° for (Z) diagonal. **3** (O) form circular. **4** Number, order and direction of strokes per letter. **5** Circular serifs. **6** Upright alphabet.

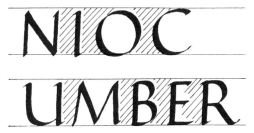

Spacing

Create an equal area between letters. The (NI) distance – approximately ⅔ width of (N) counter – sets this area.

Construction points key

A Cross-bar slightly below half-way. **B** 'Mid' point slightly above half-way, top bowl smaller, circular curves. **C** Align at front vertically. **D** Same width as (C G). **E** 'Mid' bar at or slightly above half-way. **F** 'Mid' bar at or slightly below half-way. **G** Slab serif just below half-way. **H** Cross bar slightly above half-way. **I** Restrained circular serifs. **J** Smooth join. **K** Diagonals at right angles. **L** Relate to (E). **M** (V) Part upright, match width of outside counters, steepen pen angle. (See *Characteristics key*.) **N** Steepen pen angle for uprights. **O** Smooth and circular. **P** 'Mid' point at half-way, relate shape to (B R). **Q** Note joining point of tail. **R** 'Mid' point at half-way. **S** Circular counters, top one smaller, align letter vertically at front. **T** Sides equal. **U** Same width as (H N). **V, W** Pen angle 45° for thicks, keep letters up-right. **X** Cross slightly above half-way. **Y** Cross at half-way. **Z** Pen angle 0° for diagonal, align front and back vertically.

Roman capitals in use

Learning Roman capitals in their skeleton form is a very sound beginning to calligraphy. One of the examples shown demonstrates that skeleton capitals, in addition to providing essential information about letter shape and proportion, are also useful in their own right in finished pieces of calligraphy. The other two examples show weighted Roman capitals, as demonstrated on the alphabet pages. Capitals are often neglected by newcomers to calligraphy. It is useful to consider their potential for interpreting text as well as their more obvious role for headings and line beginnings, Unlike compressed capitals, which are relatively easy to space, Roman capitals have a considerable variety of letter width; this provides a spacing challenge well worth mastering.

1 Roman capitals used in an asymmetrical block, written with a slight forward slope, together with simple illustration. *(Gaynor Goffe)*
2 Use of skeleton Roman capitals in conjunction with bold Italic for contrast. *(Christine Oxley)*
3 Roman capitals are useful for titles on formal panels of calligraphy. *(Gaynor Goffe)*

PALE STRANDS
OF CLOUDS AND FIELDS
SKY AND LAND
IN A WEAVING
OF WINTER PASTELS

1

Birth
ANNOUNCEMENT

2

ANCIENT
BUILDINGS

3

italic

a b c d e f g h i
j k l m n o p q r
s t u v w x y z

Italic

Italic is a flowing, rhythmical script character-ized by few pen lifts, springing arches, a forward slope, compressed forms and relatively steep pen angle – 45°. It developed during the Renaissance through the writing of a round humanist minuscule script with greater speed and fluency. It is useful to see historical sources of scripts; reproductions of many Italics of the Renaissance writing masters, such as Arrighi, San Vito and Palatino, are available in numerous books. A very versatile script, Italic is capable of many subtle variations and is an integral part of every calligrapher's repertoire.

Skeleton letters

inmhrkbp
adgq ceo
ltuy ffsj
vwxyz

Group **1** clockwise arches springing from just above half-way. Group **2** triangular letters. Group **3** oval letters. Group **4** anti-clockwise arches. Group **5** related top and base curves. Group **6** diagonal letters.

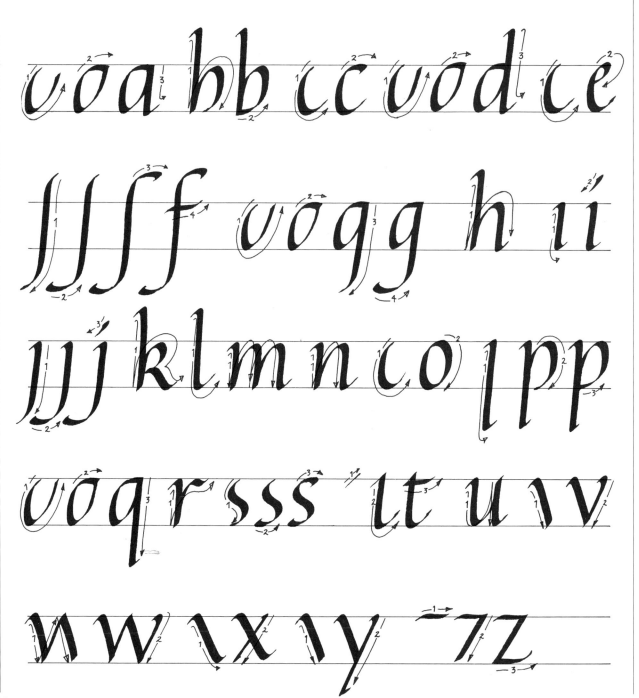

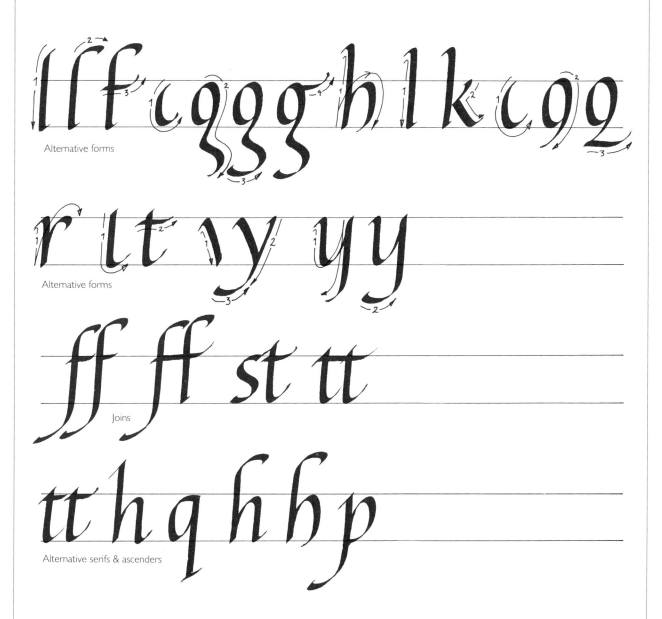

Alternative forms

Alternative forms

Joins

Alternative serifs & ascenders

Characteristics key

1 Letter weight (x-height 5 nibwidths). **2** Pen angle 45°.
3 (o) form oval. **4** Number, order and direction of strokes
per letter. **5** Springing point and joining point. **6** Oval serifs.
7 Height and length of ascenders and descenders
(about 3-4 nibwidths). **8** Forward slope about 7-12°.
9 Asymmetrical arch.

Spacing

Create an equal area between letters. The (ni) distance –
virtually the width of the (n) counter – sets this area.

Construction points key

a Keep downward strokes parallel and curves subtle.
b Flattened front curve, join base with follow-through curve.
c Back has flattened curve, keep smooth join. **d** Match body
shape and width to (a g q). **e** Relate to (o), keep top above
half-way. **f** Flowing joins, keep spacious top counter.
g Relate body to (a d q), and tail curve and join to (f j)
and oval (y). **h** Keep pen on paper for springing arch.
i Restrained oval serifs. **j** Tail as for (f g) and oval (y).
k Bowl spacious and oval, spring as for (b h m n p r).
l Smooth oval base. **m**, **n** Relate to other arched letters.
o Flattish side curves. **p** Relate body to (b). **q** Relate body
to (a d g). **r** Relate branch to (n). **s** Balance top and bottom
counters, top counter is minimally smaller, align front with
slope of script. **t** Top of cross bar on the line. **u** Reverse of
(n). **v** Central axis slopes with the script. **w** Relate to (v).
x Maintain forward slope. **y** Straight second downstroke.
z Align front and back with slope of script.

Italic in use

Italic is one of the most useful scripts to the modern calligrapher. Whether for a formal design or a freer approach, some form of this versatile script will be suitable. Italic is also a most important script for encouraging rhythmical writing. The examples show three pieces of unjoined Italic, used at the 5 nibwidths x-height demonstrated on the alphabet pages, in three different nib sizes. When you use Italic in combination with other scripts and at different weights and sizes, the design permutations are endless.

1 Excerpt from a poem The Rainy Summer by Alice Meynell, demonstrating the use of unjoined Italic in an asymmetric vertical layout. *(Gaynor Goffe)*
2 Use of Italic in a longer text, aligned left, with contrast of scale for title and credit. *(Gaynor Goffe)*
3 Use of Italic with flourishes for a simple and effective Christmas card design to be printed by photocopying or offset-litho. *(Mary Noble)*

the trees
are loud;
The forest,
rooted, tosses
in her bonds,
And strains
against
the cloud.

Alice Meynell

1

I saw a peacock

I saw a peacock with a fiery tail
I saw a blazing comet drop down hail
I saw a cloud with ivy circled round
I saw a sturdy oak creep on the ground
I saw a pismire swallow up a whale
I saw a raging sea brim full of ale
I saw a Venice glass sixteen foot deep
I saw a well full of men's tears that weep
I saw their eyes all in a flame of fire
I saw a house as big as the moon and higher
I saw the sun even in the midst of night
I saw the man that saw this wondrous sight

A N O N Y M O U S

2

3

cursive italic

abcdefghi
jklmnopqr
stuvwxyz

Cursive Italic

Cursive Italic is a lively, rhythmical script. The term 'cursive' is applied to any flowing script, and cursives may be joined by ligatures. Many forms of Italic have this innate cursive quality and can be joined together like handwriting. Cursive Italic is a more flowing variation of formal Italic, the joins developing as a result of increased writing speed. Cursive Italic can be varied in many ways: altering letter height, weight, slope, and lateral compression being a few options. The use of joined cursive Italic for handwriting will help to develop a rhythmical quality in your calligraphy.

Skeleton letters

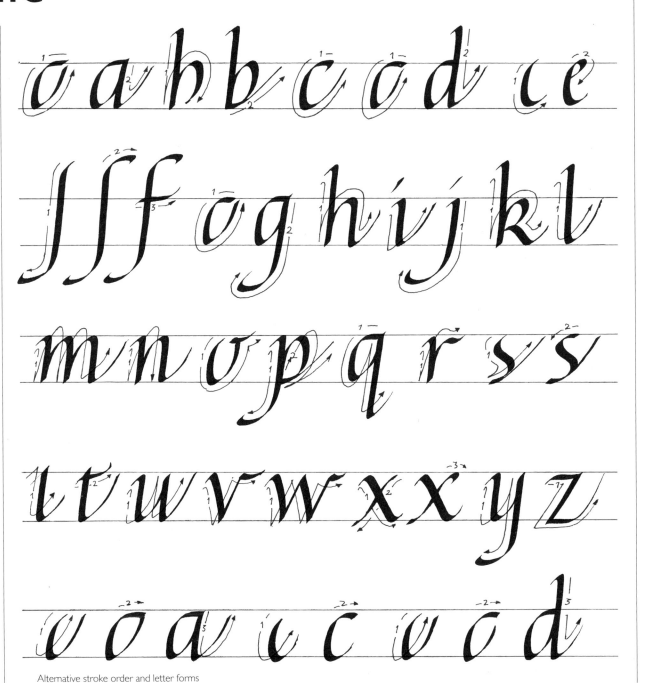

Some letters can join in more than one way.
Group **1** diagonal ligatures from exit strokes.
Group **2** diagonal ligatures from base of letter bodies.
Group **3** optional diagonal joins from letters with descenders. Group **4** horizontal joins.

Alternative stroke order and letter forms

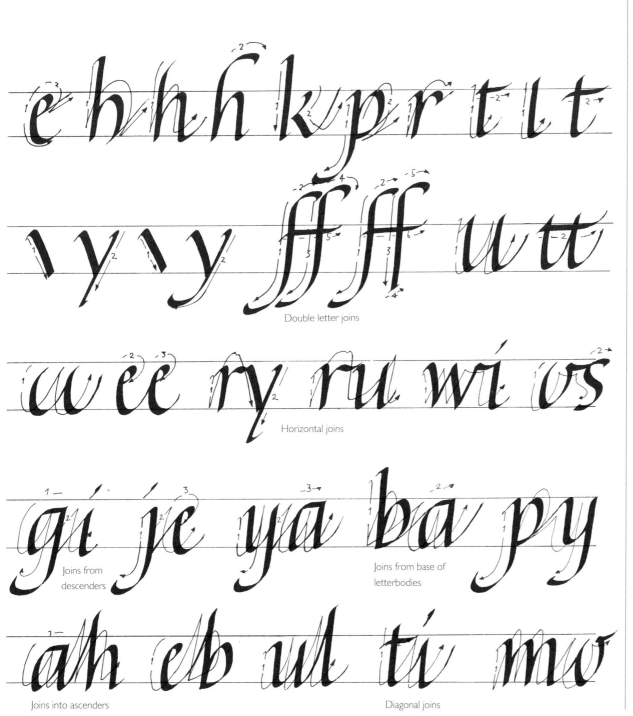

Double letter joins

Horizontal joins

Joins from descenders

Joins into ascenders

Joins from base of letterbodies

Diagonal joins

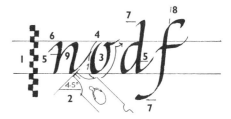

Characteristics key

1 Letter weight (x-height 5 nibwidths). **2** Pen angle 45°. **3** (o) form oval. **4** Number, order and direction of strokes per letter. **5** Springing point and joining point. **6** Oval serifs. **7** Height and length of ascenders and descenders (approximately 3–4 nibwidths). **8** Forward slope approximately 7–15°. **9** Asymmetrical arches.

Spacing

Create an equal area between letters. The (ni) distance – virtually the width of the (n)– sets this area. The diagonal joins help to obtain good spacing.

Construction points key

a Push stroke to left for 'lid'. Lighter pressure on all push strokes. **b** Push down to left for base and uphill to right in same direction for diagonal join. **c** Subtle curve from 'lid' to back. **d** Match (a g q) for shape. **e** Can join from base or middle. **f** Push stroke to left for tail. **g** Match (f j) tail shape. Can be diagonal join, start at base of letter body. **h** Match (m n) arches. **i** Flowing oval serifs. **j** Tail as for (f), can be joined, as (g), or unjoined. **k** Generous elliptical counter. **l** Match base curve to (t u). **m** Match arch shape and width in both halves. **n** Match (h) letter body. **o** Lighten pressure on uphill stroke, alternatively use formal (o), unjoined. **p** Match (b) shape for letter body and join as for (b). **q** Relate to (a d g) shape. **r** Keep arch curved not sharp. **s** Smooth counters. **t** Top of cross bar on line. Relate base curve to (l u), join from cross bar or tail. **u** Relate base curve to (n) arch. **v** Ensure same forward slope as other diagonal letters. **w** Curve horizontal joins slightly. **x** Can be joined or unjoined. **y** Can be unjoined, or join as for (g). **z** Can be joined or unjoined.

Cursive Italic in use

Cursive Italic is written at greater speed than formal Italic; it has more emphasized lead-out serifs that may be made into diagonal ligatures giving a joined Cursive Italic. The dancing quality of Italic and the horizontal linear quality of joined Cursive Italic make it very suitable for interpreting poetry and prose, where an atmosphere of flowing movement is required. The examples shown demonstrate the use of Cursive Italic at two different sizes for inscribing poetry; it is also used for a jam label which might include a simple illustration or a border. Using joined Cursive Italic for everyday handwriting is particularly beneficial to the fluency of your calligraphy.

1 Use of a joined Cursive Italic to reflect the quiet and flowing atmosphere of a Japanese *Haiku* poem.
(Gaynor Goffe)
2 Smaller scale joined Cursive Italic with simple flourishes conveys the movement of the wording, used with changes of scale for emphasis and contrast.
(Gaynor Goffe)
3 Simple use of joined Cursive Italic for a jam label.
(Gaynor Goffe)

Silent
the garden
where the
camellia tree
Opens its
whiteness

ONITSURA

1

TWO LEAPS
the water
from its race
Made to
the brook below
The first leap
it was curving glass.
The second
bounding snow

WILLIAM ALLINGHAM

2

3

Raspberry Jam

ITALIC CAPITALS

ABCDEFGHI

JKLMNOPQR

STUVWXYZ

Italic capitals

The Italic capitals illustrated here are a compressed version of Roman capitals, based on an oval of the same shape as that of Italic minuscule (lower case). Width differences between letters are less marked than with Roman capitals. During the Italian Renaissance, in the 15th and 16th centuries, Italic capitals were often elegantly and exuberantly flourished (see pages 71-74 for *Flourished Italic capitals*). The contemporary calligrapher can use Flourished Italic capitals, but they can also be used unadorned when, for example, writing quotations and poetry entirely in capitals. The forward slope gives movement to this alphabet.

Skeleton letters

OQCGD
HAVNTU
XYZ IJK
BPRSEFL
MW

Group **1** Oval letters. Group **2** Rectangular letters ¾ width of the oval. Group **3** (I J) and half width letters. Group **4** (M) is square, (W is two (V's).

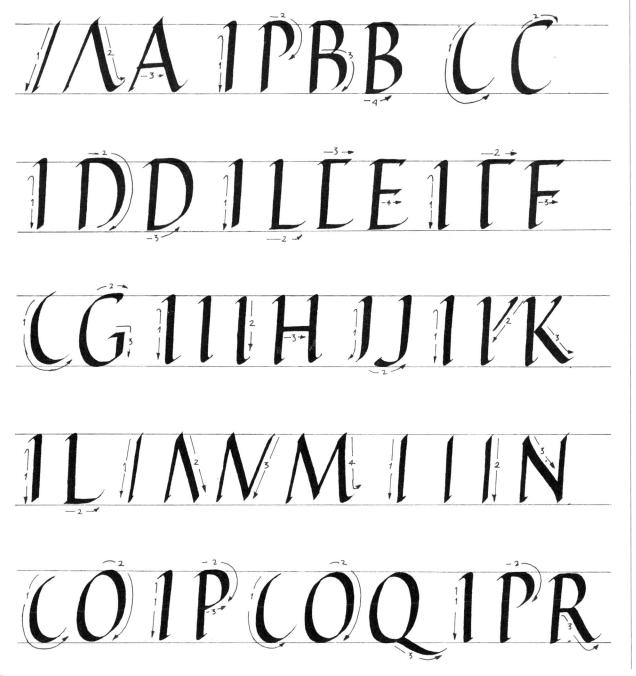

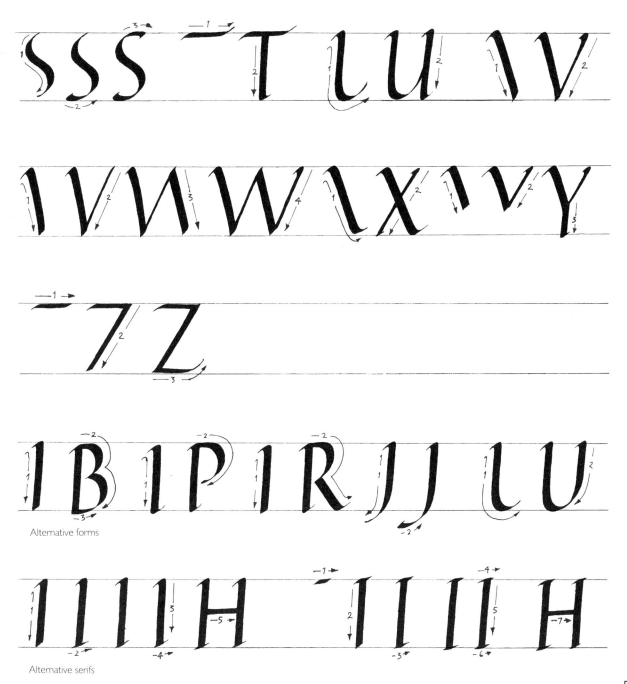

Alternative forms

Alternative serifs

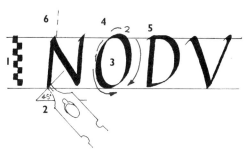

Characteristics key

1 Letter weight (x-height 8 nibwidths). **2** Pen angle 45°.
3 (O) form oval. **4** Number, order and direction of strokes per letter. **5** Oval serifs. **6** Forward slope 7–12°.

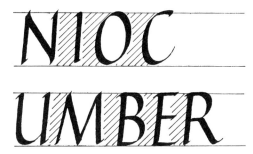

Spacing

Create an equal area between letters. The (NI) distance – approximately ⅔ width of the (N) counter – sets this area.

Construction points key

A Slope letter forwards. **B** Top bowl smaller. **C** Smooth join. **D** Same width as (C G). **E** Base arm slightly longer, middle arm at or slightly above half-way. **F** Middle arm at or slightly below half-way. **G** Centre just below half-way. **H** Cross bar slightly above half-way. **I** Restrained oval serifs. **J** Smooth curve. **K** Diagonals at right angles. **L** Relate to (E). **M** (V) part slopes forward. **N** Thin verticals – pen angle 50-60°. **O** Smooth oval. **P** Relate bowl shape to (B R). **Q** Tail attached at thinnest point. **R** Straight middle bar. **S** Top counter smaller, align letter at front with slope of script. **T** Equal sides. **U** Same width as (H N Z). **V, W** Forward slope. **X** Cross just above half-way. **Y** Cross at half-way. **Z** Align front and back with slope of script.

53

Italic capitals in use

Like Roman capitals, of which they are a compressed
form, Italic capitals are highly usable in their own right
for interpreting prose and poetry, as well as in headings.
The examples show their use in skeleton and weighted
form. The forward slope and slight uphill direction of
horizontals gives a lift and vitality to the letters. Where
different sizes of letter are used, adequate contrast is
important. Italic capitals may also be written with further
lateral compression, as well as at different weights and
sizes.

1 Use of skeleton Italic capitals in a close-knit, vertical
texture, aligned right *(Gaynor Goffe)*
2 Contrast of scale using Italic capitals in an asymmetric
horizontal layout. *(Gaynor Goffe)*
3 Italic capitals in a close-knit vertical texture, centred
layout. *(Juliet Jeffrey)*

GLASSLIKE
TONGUES OF SEA
RUNNING UP
THE DESERTED
SHORE

SKELETAL
FORM
OF SEA·WASHED
DRIFTWOOD
RECLINING IN
SUN·BLEACHED
SIMPLICITY

1

HEAVEN
NE'ER
HELPS
THE MEN
WHO
WILL
NOT ACT

3

WINGS OF BIRDS
LOW OVER THE WATER
STEAM RISING FROM LEAVES
AFTER SUMMER SHOWER
EVENING SILENCE FALLS OVER THE RIVER

2

UNCIAL

ABCDEFGHI

JKLMNOPQR

STUVWXYZ

Uncial

Uncials are capital letterforms which, though first appearing earlier, were in greatest use between the 5th and 8th centuries. There were many variations written in different parts of Europe, some with a flat pen and some with an angled pen like the alphabet illustrated here. The angled pen Uncial is flowing and has greater versatility in contemporary use. The alphabet shown here is based on the 8th-century *Stonyhurst Gospel*, which was written with quills, in North-East England. The letters were only 2mm, (½in) high; demonstrating the great skill of the scribes of that time.

Skeleton letters

cdeçhmo

pqu BRS

akvwxyz

IFJLt

Group **1** round letters based on an (O) slightly wider than a circle. Group **2** two-tier letters with related curves. Group **3** diagonal letters. Group **4** straight letters.

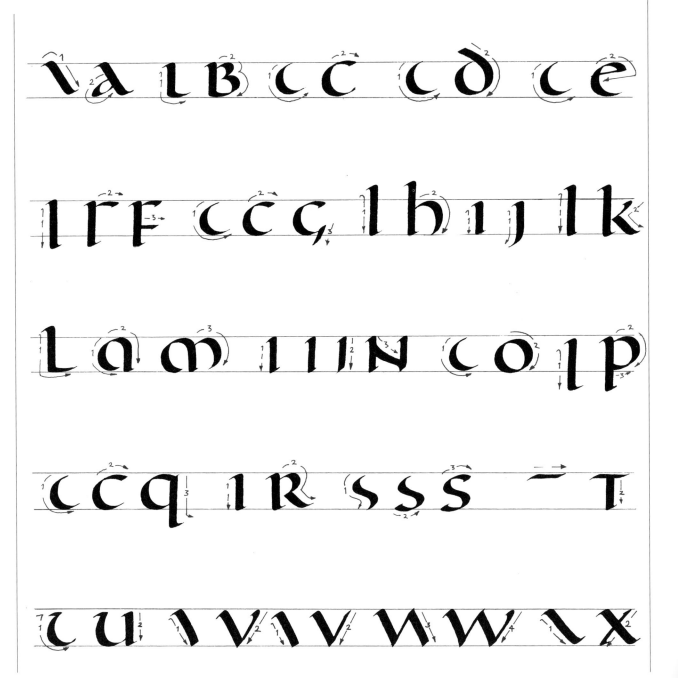

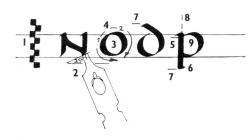

Characteristics key

1 Letter weight (height 3½ nibwidths). **2** Pen angle 25°. **3** (o) form slightly wider than circle. **4** Number, order and direction of strokes per letter. **5** High formal joins. **6** Round serifs. **7** Height and length of ascenders and descenders (approximately two nibwidths). **8** Upright alphabet. **9** Round arches.

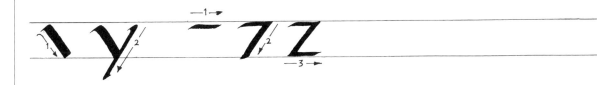

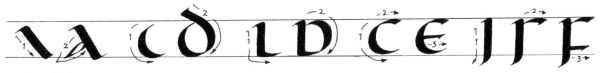

Alternative forms

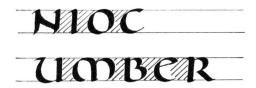

Alternative forms

Spacing

Create an equal area between letters. The (ni) distance – approximately ⅔ width of the (n) counter - sets this area.

Alternative forms

Construction key

a Join top of bowl at approximately half-way. **B** Top bowl smaller. **c** Smooth join. **d** Ascender virtually straight. **e** Top counter above half-way. **F** Generous distance between arms. **G** Relate to (C) shape. **h** Smooth and round, high formal join. **i** Restrained round serifs. **j** Taper tail off elegantly. **k** Diagonals at right angles. **L** Relate to (B). **m** Wide, smooth, rounded, relate to (h). **N** Slight curve in diagonal. **o** Slightly extended laterally, **p** High formal join of top curve to stem. **q** Relate to (C G). **R** 'Mid' point half-way or just below. **s** Top counter slightly smaller. **T** Sides equal. **U** Relate to (h) width. **v**, **w** Keep (v) parts wide and upright. **x** Keep right stroke straight. **Y** Relate to (U). **z** Align vertically front and back.

Alternative forms

Uncial in use

Uncial, whether flat pen or angled pen – as demonstrated on the alphabet pages – is traditionally a formal bookhand used from the 4th to 8th centuries. It is still useful in contemporary contexts for manuscript books. Angled-pen Uncial can also be attractive in panels of calligraphy where a soft, reasonably formal script is required. Changes of scale and letter weight can add further variety to a design. So, too, can an interesting use of space, such as the offsetting of the text areas shown in one of the examples. The roundness of Uncial makes it a suitable script for the early stages of calligraphy, as it is easier to form round shapes than the compressed shapes of a script such as Italic.

1 Panel of Uncials with text in two columns aligned to right and left to give a strong spine to the design. *(Gaynor Goffe)*
2 Illustrated poem about Cornish standing stones, showing a strong Uncial in a vertical centred layout. *(Tina Pentney)*
3 Greetings card using Uncial written with a coit multi-line edged pen, (also available in the automatic pen range). Prepared as artwork and photomechanically reduced for print. *(Gaynor Goffe)*

TALL TREES MERGE
INTO MYSTIC HUDDLE
OF SHAPE AND SHADOW
AWAY TO THE HILLS·
STARS BEGIN TO PATTERN
THE SKY AND FLOWER
IN THE DEPTHS OF
THE DARK WATER·
RIPPLES ARE TIPPED
WITH A PALE
PEARLY LIGHT
AND GROW WIDE
AND LUMINOUS AS
A NIGHT CREATURE
MOVES IN THE REEDS.

A VOICE CALLS
ACROSS THE WATER
AND THE FERRY MAKES
ITS LAST JOURNEY,
THE SPLASH OF OARS
COMING FAINTLY,
BUT WITH
A RHYTHMIC BEAT·
THE WIDENING WAKE
OF WATER SPREADS
UNTIL AT LAST
IT VANISHES IN A
TREMULOUS SIGHING,
FLUTTER UNDER
THE TREES

'GOOD COUNTRY DAYS': R·W·HOW

1

CRICKSTONE

MEN AN TOL
THROUGH THEE I CRAWL.

HOLED GREY STONE
KNIT THE BONE;

HOLED GREY BOULDER
STRAIGHTEN THE SHOULDER;

ADDER'S LINTEL
MAKE ME GENTLE;

HOLE OF THE RAIN
CHARM THE MIGRAINE;

STONE FIGURE NOUGHT
STRENGTHEN THE HEART;

HOLE OF THE WIND
STRAIGHTEN THE MIND;

NOSE-RING ON ROCK BEAST
BRING UP HARVEST;

RING OF GRANITE
STRAIGHTEN THE PLANET.

D. M. THOMAS T. PENTNEY

2

CON
GRA
TUL
ATI
ONS

3

sharpened italic

abcdefghi

jklmnopqr

stuvwxyz

Sharpened Italic

Sharpened Italic, with its characteristically angular arches and turns at the base of many letters. is a useful variation of Italic. Its compression and angularity are features that tend to develop with rapid writing, and it can be a very lively script when written vigorously.

Sharpened Italic shares many of the characteristics of less angular Italic: compression, 45° pen angle, forward slope and springing arches. By varying the letter height, slope, letter width, writing at different speeds and so on, many variations of Sharpened Italic can be developed. These include versions with slightly curved letter sides, as well as the straight-sided letters shown here.

Skeleton letters

inmhrkbp
1

adgq ceo
2 3

ltuy ffsj
4 5

vwxyz
6

Group **1** clockwise angular arches.
Group **2** anti-clockwise triangular letters joined to a right-hand 'vertical'. Group **3** anti-clockwise triangular letters. Group **4** anti-clockwise angular arches. Group **5** letters outside other categories, but having related curves. Group **6** diagonal letters.

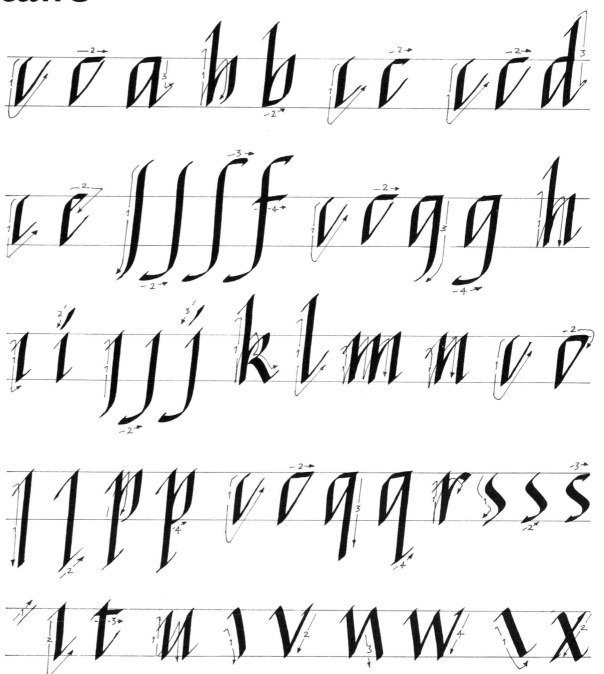

Characteristics key

1 Letter weight (x-height 5 nibwidths). **2** Pen angle 45°. **3** (o) form triangular. **4** Number, order and direction of strokes per letter. **5** Springing point and joining point – just below half-way, respectively. **6** Sharpened serifs. **7** Height and length of ascenders and descenders (approximately 3-4 nibwidths). **8** Forward slope approximately 7-12° (can be less or more). **9** Asymmetrical sharpened arch.

Spacing

Create an equal area between letters. The (ni) distance – virtually the width of the (n) counter - sets this area.

Construction points key

a Keep downstrokes parallel and all turns sharp. **b** Slight curve in springing upstroke. **c** Match shape to (a, d, g, q). **d** Relate to (a, g, q). **e** Keep top counter above half-way. **f** Keep joins angular but with some flow. **g** Relate tail shape and direction to (f, j). **h** Relate arch shape to (m, n). **i** Keep serifs sharp. **j** Relate to (f, g). **k** Keep top of bowl sharpened. Tail can be straight or have a slight curve. **l** Relate to all base turns especially (t, u). **m** Match two halves for shape and width. **n** Relate to (h, m). **o** Triangular (o). See alternatively pointed (o) at bottom of opposite page. **p** Relate to (b). **q** Relate to (a, d, g). **r** Keep branch angular. **s** Keep angular bends. **t** Relate to (l, u). Place top of cross bar on the line. **u** Inverse of (n). **v** Ensure forward slope matches rest of script. **w** Relate to (v) width, slightly narrower than two (v's). **x** Slope as for(v, w, y). **y** Straight second downstroke. **z** Align at front and back with slope of the script.

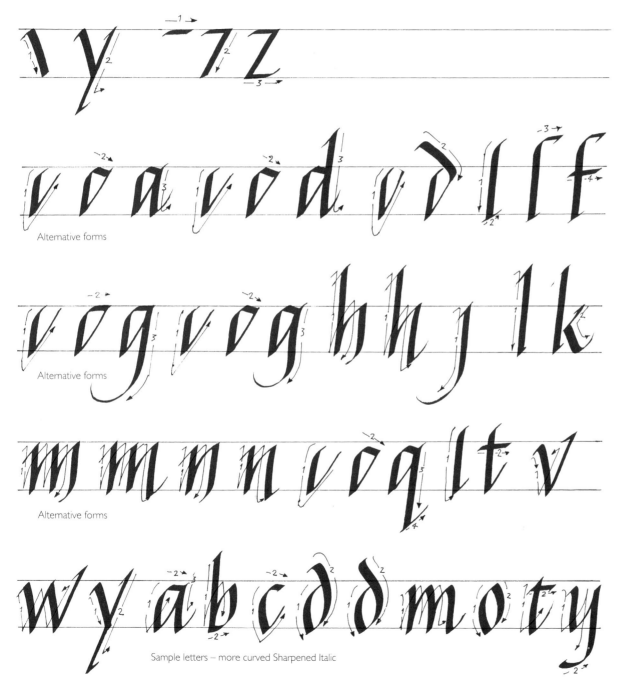

Alternative forms

Alternative forms

Alternative forms

Sample letters – more curved Sharpened Italic

61

Sharpened Italic in use

Sharpened Italic is just one of the many possible variations of Italic. Evolved during the Renaissance, it was brought to notice again during the calligraphic revival of the early 20th century, which we owe to the research and teaching of Edward Johnston. In his later work, he developed a strong angular form of Sharpened Italic (also known as Gothicized Italic because of its bold, heavy appearance) and produced some very powerful manuscripts in this striking and attractive style.

1 Sharpened Italic alphabet
(*Tom Perkins*)
2 Quotation in Sharpened Italic: Browning's *Hervé Kiel*
(*Tom Perkins*)
3 Poem by the German poet Johannes Thurnau, Sharpened Italic and freely written capitals
(*Gaynor Goffe*)

abcdefghijklmn
opqrstuvwxyz

1

Man's work is to labour and leaven –
As best he may – earth here with heaven;
'Tis work for work's sake that he's needing.

2

Ways that are
endless
must soon
END
past time is
CLOUDED
with stows
at SUNRISE
more blessed
the mass
of a world
WITHOUT
TIME
where trees
have been
SHATTERED
an inn
WITHOUT
WATER
will be
mistaken

3

gothic blackletter

abcdefghi

jklmnopqr

stuvwxyz

Gothic Blackletter

Blackletter is a decorative script which, as its name suggests, makes a bold pattern on the page. It developed, between the 12th and 15th centuries, through gradual compression and angularization of rounder scripts and was used particularly in France, Germany, the Low Countries and England. Historical variations on Blackletter include Gothic Cursive and the rounder Rotunda. Blackletter encourages even letter spacing – most of the letters being straight sided and of equal width, so the spacing distances are very regular. Although Blackletter is not very widely used in calligraphy today, partly because it is relatively illegible, it has its applications in designs requiring bold, decorative qualities.

Skeleton letters

abcdefg

hijklm

nopqrst

uuwxyz

The skeleton forms show the even letter width of this script. Because the (o) shape is so strongly reflected in the majority of the letters, there is no sub-division into formation groups.

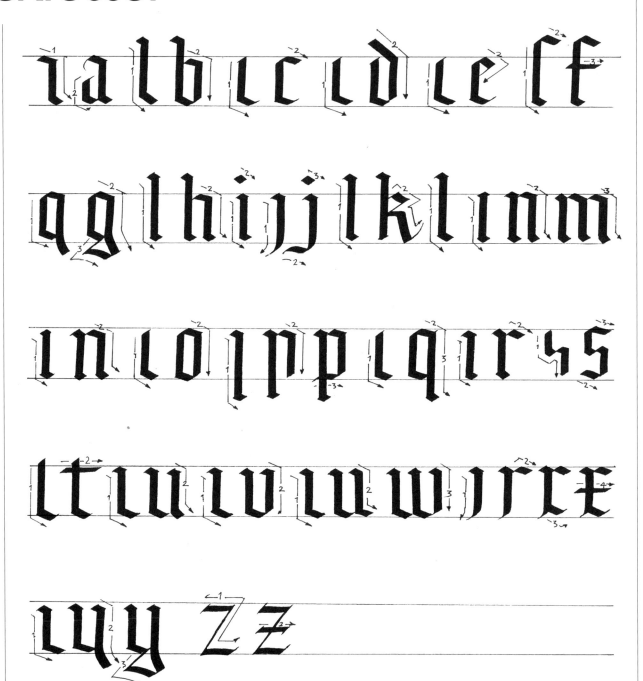

64

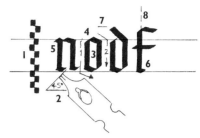

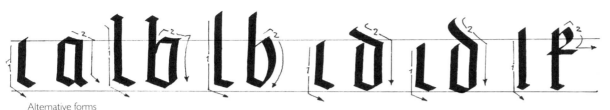

Alternative forms

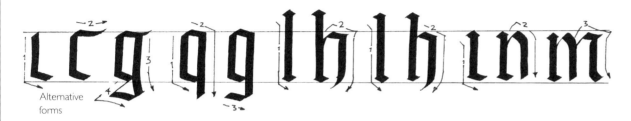

Alternative forms

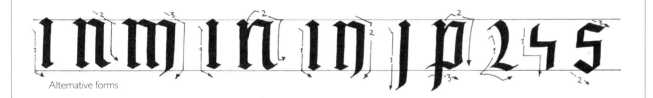

Alternative forms

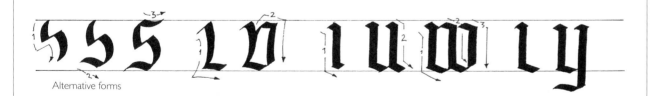

Alternative forms

Alternative forms

Characteristics key

1 Letter weight (x-height 5 nibwidths). **2** Pen angle 45°.
3 (o) form – approximating to a parallelogram. **4** Number,
order and direction of strokes per letter. **5** Arch leaves
stem high up. **6** Angular serifs. **7** Height and length of
ascenders and descenders 2 nibwidths. **8** Upright script.
9 Arches relate to (o).

Spacing

Create an equal area between letters. The (ni) distance –
the width of the (n) – sets this area. Letters are mostly
spaced equidistantly.

Construction points key

a Make hairline on nib corner. **b** Relate counter width to
(o). **c** Relate to (e). **d** Keep outside shoulders on left and
right at same level. **e** Relate to (c). **f** Shallow top counter.
g Change direction of second downstroke at base of letter
body to create adequate space in the tail. **h** Relate to (m n).
i, j Relate serifs. **k** Slightly soften bend in tail. **l** Can have
long or short base. **m, n** Relate widths, match two halves of
(m). **o** Basis of letter width for rest of the alphabet. **p** Slight
curve in base stroke of letter body. **q** Relate to (o). **r** Keep
branch narrow to facilitate spacing. **s** Align at front vertically.
t Top of cross bar on the line. **u** Base relates to (n) arch.
v, w Counters same width as (o). **x** Relate width to (o).
y Relate tail to (g). **z** Same pen angle for whole letter.

Gothic Blackletter in use

The following examples show some functional contexts in which Blackletter is appropriate in calligraphy today. Its decorative quality is particularly suited to celebrations and festive occasions. Blackletter can have a very strong presence. It can be written with considerable freedom and rhythm, as practised by some of the well-known German calligraphers earlier this century, particularly Rudolph Koch who wrote some very powerful texts in this script. It is a good learning discipline in its more formal regular mode because of the necessary regularity of the straight vertical letter strokes and consequent equidistant letter spacing.

1 Blackletter used to give a bold atmosphere to a quotation from Shakespeare. *(Gaynor Goffe)*
2 An early music concert programme title – Blackletter is an appropriate script in keeping with the subject. *(Gaynor Goffe)*
3 Title for a lecture on the subject of the Middle Ages. *(Gaynor Goffe)*

Glory is like a circle
in the water SHAKESPEARE
Which never ceaseth
to enlarge itself
Till by broad spreading,
it disperses to nought.

KING HENRY VI PART I

1

Concert of
Fourteenth Century
Music

2

Life in
the Middle Ages

3

66

VERSALS

ABCDEFGHI

JKLMNOPQR

STUVWXYZ

Versals

Versals were widely used in illuminated man-
uscripts, particularly in the 9th and 10th
centuries. These pen-made, built-up letters,
characterized by thick stems and thin serifs,
are so called because they were used at the
beginning of verses. Sometimes several lines
were written in coloured Versals with larger
decorated Versals at the start of important
passages. The most elegent historical exam-
ples are based on the proportions of Roman
inscriptional capitals (the basis for the
alphabet shown here). Versals can make a
refined addition to contemporary calligraphy.
The example here uses an upright letter,
although it is possible to slope and also
compress Versals.

Skeleton letters

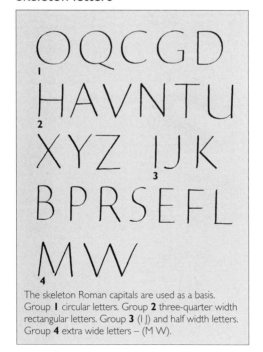

The skeleton Roman capitals are used as a basis.
Group **1** circular letters. Group **2** three-quarter width
rectangular letters. Group **3** (I J) and half width letters.
Group **4** extra wide letters – (M W).

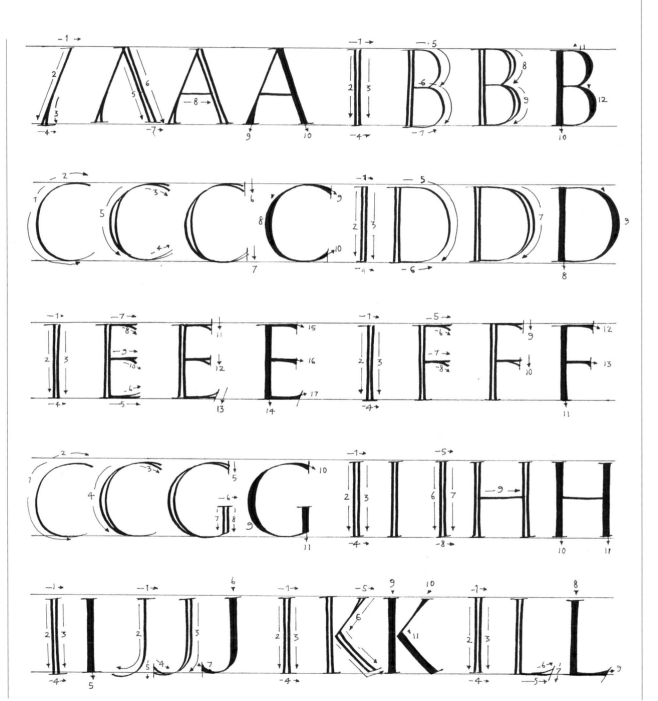

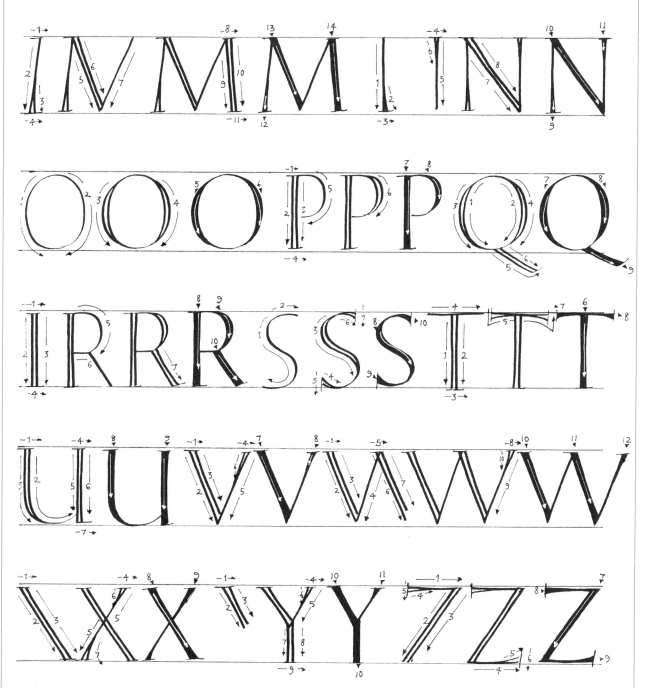

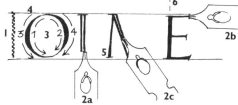

Characteristics key

1 Letter height (height 24 nibwidths). This is 8 stem widths, the vertical and diagonal thick stems being 3 nibwidths wide – two outer strokes and third to fill in. A no 5 Rexel nib is used in the example alphabet. **2** Pen angle: for all straight strokes the pen angle is at right angles to the stroke direction. **2a** 0° (horizontal nib) for horizontal serifs and thick vertical stems, outside strokes of curves, thin diagonals and (Z) diagonal. **2b** 90° (vertical nib) for vertical serifs and straight horizontal strokes. **2c** Approximately 20° for inside strokes of curves and thick diagonals except (Z).
3 (O) form, oval inside, circular outside. **4** Number, order and direction of strokes per letter. **5** Serifs, straight and fine. **6** Upright letters.

Spacing

Create an equal area between letters. The (NI) distance – approximately ⅔ width of (N) counter – sets this area.

Construction points key

A Shaping on open end of thin strokes starts about ⅓ the way up the letter and is gradual. **B** Middle bar slightly above half way. Inside curves oval, outside circular. **C** Smooth follow-through curves. **D** Relate width to (C G). **E** Middle arm at or slightly above half-way, subtle shaping of open arms, bottom serif at an angle. **F** Middle arm slightly below half-way. **G** Relate width to (C D). Middle serif slightly below half-way. **H** Cross bar slightly above half-way. **I** Thick stem width (3 nibwidths) – two outside strokes and a fill in stroke. **J** Gradual curve. **K** Diagonals meet at right angles. **L** Relate to (E). **M** Two outside counters equal width. **N** Width of diagonal the same as thick vertical stems. **O** Oval inside, circle outside. **P** Relate to (B R). **Q** Join tail to thinnest part of curve at base. **R** Middle bar at half-way. Relate tail shape to (K). **S** Circular counters, thick stroke equal to thick stems. **T** Both sides equal. **U** Relate base arc to (O). **V, W** Thick diagonals equal in width to thick verticals. **X** Cross slightly above half-way. **Y** (V) section and stem meet at half way. **Z** Match diagonal width to thick stems.

Versals in use

The subtle waisting of thick stems and the tall letter height relative to the thin nib required for their construction make Versals a challenging, but rewarding letterform to write. Versals are capable of great variation: changing the letter height, the weight (stem thickness), slope, letter width (compressed or expanded) and writing without serifs (in which case they would be called Compound capitals rather than Versals). To begin with, it is best to confine Versals to verse beginnings and headings, as they demand a high level of skill. As well as learning classical letter shapes for Versals based on the proportions of Roman capitals, it is worth investigating some of the other more decorative Versal letter shapes from the Middle Ages; these can be used as a spring-board for your own contemporary Versal variations.

1 Extract from a poem by George Borrow showing Versals in a close-knit vertical layout. *(Gaynor Goffe)*
2 Use of an initial Versal to start off a quotation in Italic. The Versal may be pen-made or drawn and painted. Such initials are often gilded. This simple decoration would be painted with watercolour. *(Gaynor Goffe)*
3 Versals used in conjunction with illustration, which would be painted in, for a greetings card. *(Gaynor Goffe)*

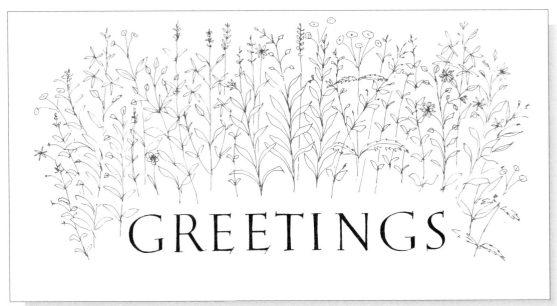

THERE'S
NIGHT AND
DAY
BROTHER
BOTH
SWEET
THINGS

GEORGE BORROW

1

Autumn hedgerow's rich harvest blending of gold, red and purple

2

GREETINGS

3

FLOURISHED CAPITALS

A B C D E F G H I
J K L M N O P Q R
S T U V W X Y Z

Flourished capitals

Flourished Italic minuscule and capitals appeared during the Italian Renaissance. Flourishes are flowing, decorative lead-in and lead-out strokes on compressed Roman capitals and Italic minuscule and are natural extensions of the letters, when written fluidly. Their design potential is endless and it is an enjoyable challenge to develop flourishes appropriate to each project. They should enhance the lettering and flow organically into and out of letters. Practise with a pencil or chisel-ended felt pen. Renaissance and contemporary examples from book reproductions provide a useful springboard for making your own designs.

Skeleton letters

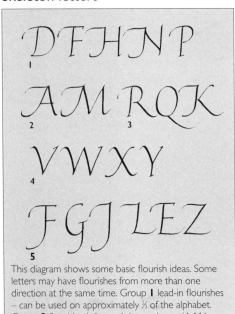

This diagram shows some basic flourish ideas. Some letters may have flourishes from more than one direction at the same time. Group **1** lead-in flourishes – can be used on approximately ⅔ of the alphabet.
Group **2** flourished diagonal descenders – (A M).
Group **3** flourished diagonal tails – (K Q R).
Group **4** diagonal lead-in flourishes – (V W X Y)
Group **5** vertical downstrokes –(F G J).

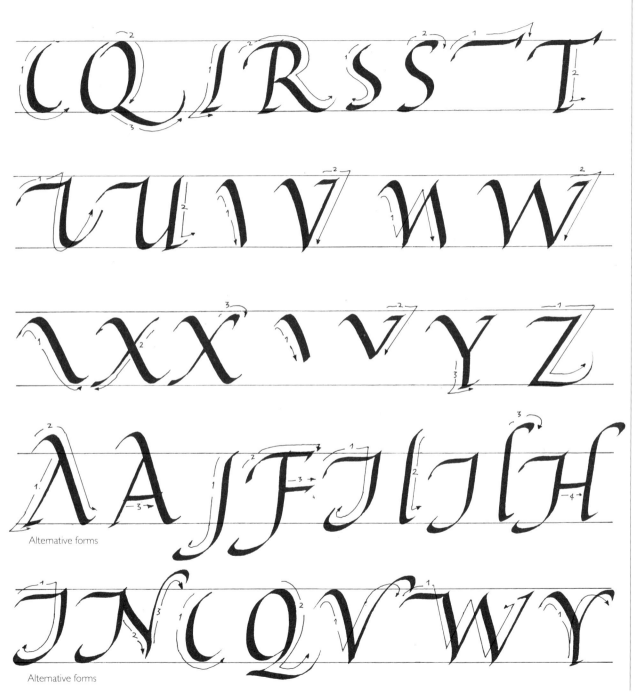

Alternative forms

Alternative forms

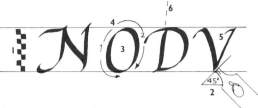

Characteristics key

1 Letter weight (height 8 nibwidths). **2** Pen angle 45°.
3 (O) form oval. **4** Number, order and direction of strokes per letter. **5** Serifs – various possibilities including oval hooks and slabs. **6** Slope – slight forward slope 7–15°.

Spacing

It is possible to use words written entirely in flourished capitals – for example for a heading, in which case, spacing is based on the spacing pattern for Italic capitals and flourishes between letters kept minimal. It is more usual to use flourished capitals in conjunction with Italic minuscule.

Construction points key

A Slight movement in lead-in flourish. **B** Write entire top in one continuous stroke leading into curves of letter body. **C** Smooth and flowing. **D** Shape top as for (B). **E** Slight movement in horizontal base all one stroke. **F** As (E). **G** Smooth curve into tail flourish. **H** Middle stroke can be written second to ensure flow. **I** Flowing flourish. **J** Top as for (I), tail as (G K). **K** As (J), with fluid tail. **L** As for (E). **M** Flourish diagonal as for (A), it can be more ornate than the example illustrated. **N** Outside strokes parallel. **O** Smooth and flowing. **P** As for (B R). **Q** Fluid tail as for (K R). **R** Relate top to (B R), tail to (K Q). **S** Sinuous and flowing, extend bottom half of letter if required. **T** Flourished lead-in and lead-out of cross bar. **U** One fluid movement. **V**, **W** Ensure forward slope, no pen lifts. **X** Cross slightly above half-way. **Y** Keep symmetrical (V) part. **Z** Lead in and out of letter rhythmically.

73

Flourished capitals in use

Flourished capitals offer unlimited scope. It is fun to experiment and invent your own Flourish designs. However, referring to good Renaissance examples provides a good starting point. Flourishes should have a certain tension of form, but, at the same time, should be fluid and spontaneous. Practising flourishes with a felt-tip pen, chisel-edged or monoline, encourages the necessary smooth, flowing movement. The examples illustrate a variety of designs for capitals and Italic minuscles; the same principles apply to both. In general, they should be spacious to give elegance – the movement of the flourish starts before the pen touches the paper and continues after the flourish is finished.

I Design showing a variety of flourished Italiccapitals and Italic minuscule using an automatic large-scale pen and a variety of Rexel nibs. *(Gaynor Goffe)*
2 Flourished Italic capitals using a multiple stroke coit pen; similar effects can also be produced with automatic pens. *(Gaynor Goffe)*
3 Flourished Italic is useful for decorative headings for calligraphic panels. *(Gaynor Goffe)*

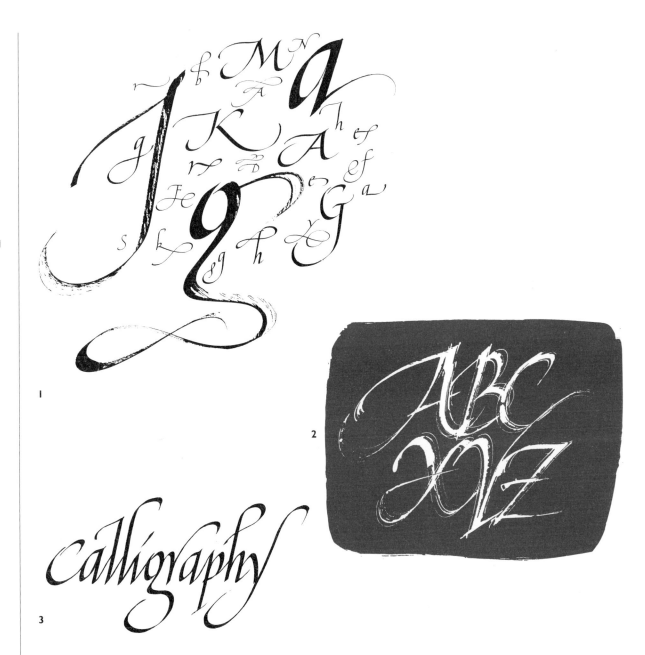

NUMBERS

1234567

890 123

4567890

Numbers

Numbers should harmonize with the script. The Arabic numbers shown can be used with most scripts, except angular ones. Upright or sloping numerals may be used with sloping scripts, such as Italic. They may be aligned with the script top and bottom, or have ascenders and descenders. Ranged numbers are generally used with text in capitals for a neat appearance, while non-ranged numbers are used with minuscule text, the ascenders and descenders being in keeping with the minuscule script. Zero is always compressed to differentiate it from the letter (O). Roman numerals (e.g. III, VI, XII) can be derived from Roman capital letters.

Skeleton numbers

Upright, ranged

Upright, ranged

Upright, ranged

Upright, non-ranged

Upright, non-ranged

Shown here are skeleton forms for upright, ranged numbers and slightly sloping, compressed ranged numbers. Non-ranged numbers may also be rounder and upright or sloping and compressed. Group **1** upright, ranged numbers based on a slightly flat-sided circle, all curves relate to this. Group **2** compressed, slightly sloping, ranged numbers, based on an oval of similar proportion to italic capitals.

Upright, non-ranged

Sloping, compressed, ranged

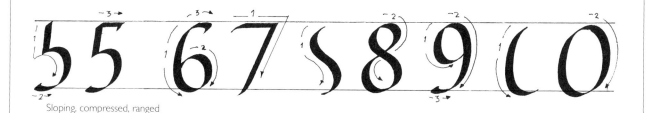

Sloping, compressed, ranged

Sloping, compressed, non-ranged

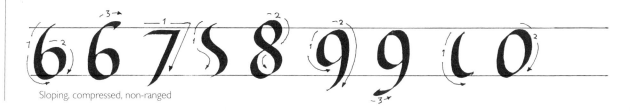

Sloping, compressed, non-ranged

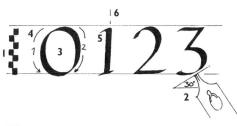

Characteristics key – Group 1

The aligned numbers shown are based on a circular form, with the exception of the zero, which is slightly compressed to differentiate it from the letter (O). The non-aligned numbers are based on an oval of similar proportion to the (O) of Italic capitals.

Characteristics key – Group 2

1 Weight: height 7 nibwidths for ranged upright numbers, 4½ nibwidths for non-ranged upright numbers (as for Foundational hand), 8 nibwidths for ranged, sloping and compressed numbers, and 5 nibwidths for non-ranged, sloping, compressed numbers. **2** Pen angle 30° for upright circular numbers, 40/45° for compressed numbers. **3** (O) form, circular, or oval for zero and slightly compressed numbers. **4** Number, order and direction of strokes per number. **5** Top serifs are usually curved or built-up triangles, base serifs are curved or slab serifs. **6** Height and length of ascenders and descenders to match the minuscule script with which they are used. **7** Slope, compressed numbers slope to match accompanying script

Spacing – *See following page*

Construction points key

Upright numbers
1 Rounded top serif, slab base serif for stability (other serifs are also possible). **2** Bowl circular and slight 'sag' in the diagonal. **3** Circular base. **4** Slight thickness to diagonal, enclose generous counter space to relate to other numbers. **5** Circular bowl relating to (3). **6** Circular bowl related to (9). **7** Slight curve at base of diagonal. **8** Keep vertical, with generous counters, top slightly smaller. **9** Relate to (6). **0** Smooth flattened-sided circle to distinguish it from letter (O).

Non-ranged upright numbers are related to each other for shape in a similar way to ranged numbers. (1 2 0) sit between the lines, (3 5 7) align with the top line, with descenders below the bottom line, (4 6 8) align with the base line, with ascenders projecting above the top line.

Compressed, sloping numbers: as for upright numbers with the main difference being that curves relate to a narrower sloping oval.

Numbers in use

Numbers should harmonize with the script they accompany but do not necessarily have to match it. For example, you can use upright, rounded numbers or compressed, oval-based numbers with Italic minuscule. The following examples show that, in some contexts, numbers need to be written with the same nib size as the accompanying script; in other cases, the design may require the numbers to be larger or smaller in scale. It is also possible to design looser, more flowing numbers if appropriate to the design context.

1 Ranged, upright numbers with Roman capitals; non-ranged, upright numbers with Foundational hand; ranged, compressed and sloping numbers with Italic minuscule; non-ranged, compressed, sloping numbers with Italic minuscule *(Gaynor Goffe)*
2 Numbers used for dates on formal calligraphic panels; non-ranged upright numbers used together with Foundational hand *(Gaynor Goffe)*
3 Numbers used on a recipe; compressed, sloping non-ranged *(Gaynor Goffe)*

Spacing – Group 1 *Page 76*

Upright numbers are spaced similarly to Roman capitals, the compressed, sloping numbers are spaced similarly to Italic capitals. Numbers need generous spacing to avoid cramping.

Spacing – Group 2 *Page 77*

Like letters, numbers should have an equal area of space between them. Round and compressed numbers are spaced similarly to Roman capitals and compressed italic capitals respectively.

3RD APRIL 1862
25th November 1994
30TH FEBRUARY 1721
17th January 1653

1

1967–1975 Louis Hague
1975–1978 Michael Harrison
1978–1984 John Lefevre
1984–1990 Simon Peterson
1990– Anthony Du Pont

2

CHERRY CAKE

225g sugar 112g glacé cherries
175g margarine 4 tablespoons milk
3 eggs grated lemon rind
500g self-raising flour 6 drops vanilla essence

Cream the margarine, add sugar and cream
again. Add the eggs and beat. Sift the flour,
add milk gradually. Stir in the rind, essence
and cherries. Turn the mixture into a tin.
Bake in a moderately hot oven at 375 degrees
for one hour, or until the cake is golden brown.

3

PROJECTS

Invitation

An invitation is a useful and interesting design project for the inexperienced calligrapher who has achieved a basic competence with one or two scripts. Whether the invitation is for a formal occasion, such as a wedding or classical musical concert, or for a more casual function, such as a wine-tasting, calligraphy can create the right atmosphere.

The number of invitations normally required will mean that you will have to pre-pare pasted-up artwork for the printer. This straightforward process requires the design to be written in black ink and pasted up on white card, ready for photographic processing and printing. Offset-litho is the most frequently used printing process for reproducing calligraphic artwork. However, good quality photocopying – in colour, if required – can produce reasonable results if the number of copies, or the budget, is low. For more than a certain number of copies, offset-litho printing will be more economical than photocopying and the choice of paper type, thickness and texture is much greater. Consult your local printer, before producing final artwork, for a comparison of quality and cost. Prices for printing can vary enormously, so it is worth seeking several quotations.

1

1 If you are working for a client, obtain an accurate text before starting – any corrections at a later stage can be very frustrating and time-consuming. Read the wording and decide what you wish to emphasize. Make thumbnail pencil sketches of layout possibilities, bearing in mind the necessity of line breaks to separate such information as date, location and reception.

2 Find out the required final invitation size from the client as this will affect the scale at which you choose to work. Decide whether to work at the same size or larger, and choose appropriate nib sizes to make trials. You can then write a line of the main text in a few different styles, (and sizes if necessary), to make a selection appropriate to the occasion. Figure 2 shows some writing trials, using a Rexel no. 4 nib: various Italics (four versions), Foundational hand, Uncial, various capitals (three versions).

Mr and Mrs J. Nolan Smith
Mr & Mrs J. Nolan Smith
Mr and Mrs J. Nolan Smith
Mr & Mrs J. Nolan Smith
Mr and Mrs J. Nolan Smith
MR & MRS J. NOLAN SMITH
MR & MRS J. NOLAN SMITH
MR & MRS J. NOLAN SMITH
MR & MRS J. NOLAN SMITH

2

Mr and Mrs J. Nolan Smith request the pleasure of your company at the wedding of their daughter at the church of St. Francis, Bembridge at 2 pm on Saturday.

3

3 Having decided on the style and nib size for the main text, write out all the text in black ink on layout paper, except the parts you wish to emphasize by using a different size or style.

When working for print, it is usual to work larger than actual size, but your paste-up design must be to the same proportions as the final printed item. (See page 20 *Useful processes.*) It is best not to work too much larger, as the lettering will lose strength if the reduction is very great, whereas a slight reduction has the advantage of sharpening the strokes. The project illustrated here was worked out at A4 size and reduced at the printing stage to the final A5 size.

4 Write out the other text elements – those that you wish to emphasize – trying larger nibs and different styles. Also make design trials on layout paper, in colour if appropriate, for any other features, such as the initials at the top of the invitation and the border design. Work initially in pencil and then colour the design, either with a fine pointed nib or very fine paintbrush (size 0 or 00).
4a nib sizes Rexel 3, 2½, 2
4b nib size Rexel 2½

Victoria

Victoria

Victoria

4a

4b

Mr and Mrs J. Nolan Smith
request the pleasure of your company
at the wedding of their daughter

Victoria
to
Mr Max von Christenburg

at the Church of St. Francis, Bembridge
at 2 pm on Saturday, 20th August 1994
and afterwards at the Bembridge Country Club

5

5 Cut up the text into lines and place them and the other design elements on a background sheet of white card and see whether the number and length of lines will tend towards a vertical or horizontal layout. Consider whether you want an aligned left, centred or asymmetrical layout. As you place the text lines down in sequence, consider the appropriate interline space. To emphasize a vertical layout you may need a generous interline space, whereas to retain a horizontal layout you may need to keep a small interline space to prevent the layout getting too square.

It is essential to check the exact proportions of the invitation at this stage before you commence the paste-up. (See page 20 *Useful processes – pasting up*.)

6 When you are satisfied with the design, paste up the complete layout, including the decorated initials, border and so on with rubber cement solution. (See page 20 *Useful processes* for paste-up method.) All the artwork must be in black and white ready for printing. Assess margins (see page 16 *General principles of layout*), and mark in the corners with crosses to indicate the outer limits of the design for the printer. To get your layout exactly in proportion you may need to adjust the line spacing and/or the margins to achieve the exact height/width proportion.

As a final check you can photocopy your artwork down to the printed size.

If you want the calligraphy on the printed invitation to be in colour, you may wish to make a colour rough at this stage to test how the different design elements work together in colour, and to obtain the approval of your client. This can be cut and pasted on layout paper.

Write instructions to the printer on an overlay sheet attached to pasted up artwork. Indicate the reduction required. If the invitation is to be in more than one colour, these instructions should also be clearly marked on the overlay. As long as the elements to be printed in different colours do not touch or overlap, all the artwork can be on one sheet, as in this project. If any of the elements do touch or overlap, then those designed to be in a second colour must be pasted up in their correct position on a separate sheet and the corners marked accurately to coincide with the corner marks on the main artwork. This is called registration. The printer will also need to know if it is to be a single sheet or folded invitation and what weight of paper or card you require. (They will have samples of a wide range of papers from which you can chose and can advise on the suitability of papers to your project.) Any colours should be indicated with a small colour sample or reference number from one of the colour systems widely used in printing.

VM

Mr and Mrs J. Nolan Smith
request the pleasure of your company
at the wedding of their daughter

Victoria
to
Mr Max von Christenburg

at the Church of St. Francis, Bembridge
at 2 pm on Saturday, 20 th August 1994
and afterwards at the Bembridge Country Club

R S V P

ST. HELEN'S HOUSE, BEMBRIDGE,
ISLE OF WIGHT IW2 34Z

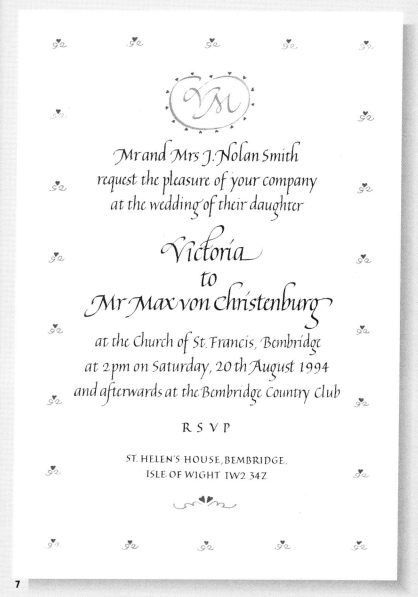

VM

Mr and Mrs J. Nolan Smith
request the pleasure of your company
at the wedding of their daughter

Victoria
to
Mr Max von Christenburg

at the Church of St. Francis, Bembridge
at 2 pm on Saturday, 20 th August 1994
and afterwards at the Bembridge Country Club

R S V P

ST. HELEN'S HOUSE, BEMBRIDGE,
ISLE OF WIGHT IW2 34Z

7

7 The final printed invitation in A5 size, that is, 210 x 148mm (8¼ x 5 ⅞in).

Change of address card

This is a straightforward project and an item that most calligraphers will be called upon at some time to design for themselves, friends or clients. For the finished item, the black and white paste-up artwork can be photocopied in black or colour onto good quality, white or coloured paper. Offset-litho is another printing process to consider. It is more expensive than photocopying for small quantities, but comes into its own when several hundred copies are required. It also has the advantage of higher printing quality, with a wider choice of paper/card thickness, colour and texture, and a greater choice of colour. Printing is usually in one colour – possibly two – as a change of address card is a low budget item. Ask your local printer for a quotation, and the best way to present the artwork for reproduction, before starting the project.

Photocopying is very useful in the design process. It enables you to enlarge or reduce your writing trials and re-combine the design elements to produce a wider variety of designs at the rough stage. This is particularly helpful if you are new to calligraphy and can use only one or two scripts. Trying combinations of different sizes can trigger new ideas. There is considerable flexibility in the size and shape of the printed card, but bear in mind that standard 'A' sizes are more economical when printing.

This project requires the production of artwork for print.

1 Make thumbnail pencil sketches of design ideas on layout paper (figures 1a, b, c, d).

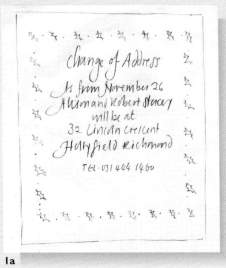

1a

1d

1b

1c

2 Decide the approximate size of the printed card so that you can gauge what scale to work at. You may not know the exact proportions of the card until you have made the rough paste-up designs, unless a size has been stipulated by a client or you want to work to a particular proportion. You can work at the actual size or larger. The printed card is likely to be approximately A6 size, that is, 105 x 74mm (4⅛ x 2¹⁵⁄₁₆in); it might be A5 size (the equivalent of two A6 cards placed together with their longest sides touching), but is unlikely to be larger. It may be easier for the printer if you work to a recognized printing size, but it is not essential for this project as the card may be in any proportion you choose. Make writing trials of the full text in different styles and nib sizes, on layout paper in black ink, ruling up the x-height accurately for each script. You can photocopy the writing trials at different sizes before cutting up the text to make layouts so that you can examine different design possibilities.

As from November 26

As from November 26

As from November 26

AS FROM NOVEMBER 26

AS FROM NOVEMBER 26

2a

2a Main text: heavyweight Italic, lighter-weight smaller Italic, sloping capitals, lightweight sloping capitals.

2b Heading: Three examples of formal Italic with various designs of ascenders and descenders, cursive Italic, sloping capitals, large and small Roman capitals, flourished capitals.

Change of Address

Change of Address

Change of Address

Change of Address

CHANGE OF ADDRESS

CHANGE OF ADDRESS

CHANGE OF ADDRESS

CHANGE OF ADDRESS

2b

3 Cut up and arrange the text into layouts on a background sheet of white card. When layouts are satisfactory, paste-up with rubber cement solution (see page 20 *Useful processes – Pasting-up*). Diagrams 3a, b, c, d, e, show a selection of paste-up designs. It may be apparent at this stage that some of the designs need a different heading – perhaps larger, smaller or in a different style. If this is the case, write out these new elements, arrange them and paste them up. Take special care to align all the elements accurately and to ensure that the glue does not get onto your fingers or the top surface of the photocopied elements.

Change of Address

AS FROM NOVEMBER 26
ALISON AND ROBERT STACEY
WILL BE AT 32 LINCOLN CRESCENT
HOLLYFIELD · RICHMOND
TEL · 031 444 1460

3a

Change of Address

AS FROM NOVEMBER 26
ALISON AND ROBERT STACEY
WILL BE AT 32 LINCOLN CRESCENT
HOLLYFIELD · RICHMOND
TEL · 031 444 1460

3b

CHANGE OF ADDRESS

AS FROM NOVEMBER 26
ALISON AND ROBERT STACEY
WILL BE AT 32 LINCOLN CRESCENT
HOLLYFIELD · RICHMOND
TEL · 031 444 1460

3c

change of Address

As from November 26
Alison and Robert Stacey
will be at
32 Lincoln Crescent
Hollyfield·Richmond

TEL · 031 444 1460

3d

CHANGE OF ADDRESS
As from November 26
Alison and Robert Stacey
will be at
32 Lincoln· Crescent
Hollyfield·Richmond

TEL·031 444 1460

3e

4 If there are any additional elements, make trials on layout paper at this stage. By positioning the layout paper over the artwork, it is easy to see if these elements are to the required scale. A small holly leaf motif was tried for this project and pasted-up on the selected design. The main text was written with a Rexel 3½, the heading with a 2½.

Decide on the size and position of the margins by placing four coloured strips of card or paper round the design, and moving them in and out to compare results. (See page 16 *Principles of layout – Margins*.) Mark in the corners to indicate the outer limits of the design to the printer.

Change
of Address

AS FROM NOVEMBER 26
ALISON AND ROBERT STACEY
WILL BE AT 32 LINCOLN CRESCENT
HOLLYFIELD · RICHMOND
TEL · 031 444 1460

4

Change of Address

AS FROM NOVEMBER 26

5 You can experiment with colours on layout paper or simply choose a colour from the printer's colour reference chart. If you want to match a particular colour, paint a reasonably large area – say 100mm (4in) square – on a piece of paper. This will help the printer to make an accurate match. If the card is to be printed in more than one colour, indicate clearly, perhaps on a photocopy of the artwork, which elements print in which colour.

6 The final printed card. If you have produced your artwork at a larger size than the finished card, indicate clearly what the printed size should be.

Change of Address

AS FROM NOVEMBER 26
ALISON AND ROBERT STACEY
WILL BE AT 32 LINCOLN CRESCENT
HOLLYFIELD · RICHMOND
TEL · 031 444 1460

An illustrated poem – *My Shadow*

Historically, the art of illumination – gilding and painting decorated letters and illustrations – is an integral part of creating a manuscript. The skills of writing and illuminating blend harmoniously in many exquisite Mediaeval and Renaissance manuscripts. Nevertheless, calligraphy is so versatile that in contemporary work, where its function is quite different from that of the past, it is often used alone, evoking the appropriate response without further decoration.

There is also much contemporary work that does include illustration and this introduces a different quality. Using colour with calligraphy ranges from the creation of a painting which includes letters to a more conventional piece of calligraphy with illustration. Although drawing and painting skills are very useful to a calligrapher, they are not essential. There are many simple forms of illustration, such as symbols and simple flower and leaf designs, that you can adapt even if you have little drawing experience.

You need to consider the following points when combining calligraphy and illustration. They should be in harmony; the illustration of a scale that creates the desired effect and works with the calligraphy. The medium used depends on the effect required and on the style, weight, size and amount of text. Choices include watercolour, pen and wash drawing, gouache, pencil crayon, and pastel. The placing of the illustration is important, as it should integrate with the calligraphy. Simple borders are a good way to try out integrating illustration and calligraphy for the first time.

The illustrated poem shown here was designed as a panel for a child.

1a

1b

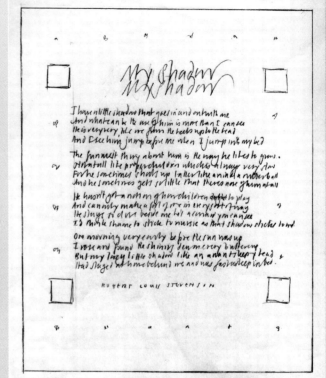

1c

1 Read the words carefully and make thumbnail pencil sketches of layout and script ideas (figures 1a, b, c). Your ideas will depend on your level of experience and the purpose of the panel. As this is a long poem, a simple layout is advisable, particularly for an inexperienced calligrapher, allowing you to give your full attention to letterform and spacing.

I have a little shadow that goes
I have a little shadow that goes
I HAVE A LITTLE SHADOW THAT GOES
I HAVE A LITTLE SHADOW THAT GOES

2a

My Shadow
My Shadow
MY SHADOW
MY SHADOW

2b

MY SHADOW

I have a little shadow that goes in and out with me,
And what can be the use of him is more than I can see.
He is very, very like me from the heels up to the head;
And I see him jump before me, when I jump into my bed.

The funniest thing about him is the way he likes to grow
Not at all like proper children which is always very slow;
For he sometimes shoots up taller like an india-rubber
And he sometimes gets so little that there's none of him at all.

He hasn't got a notion of how children ought to play,
And can only make a fool of me in every sort of way.
He stays so close beside me, he's a coward you can see;
I'd think shame to stick to nursie as that shadow sticks to me!

One morning, very early, before the sun was up,
I rose and found the shining dew on every buttercup;
But my lazy little shadow, like an arrant sleepy-head,
Had stayed at home behind me and was fast asleep in bed

3

2 Decide the approximate size of the panel before making any writing trials, so that you can use the appropriate nib sizes. Then make your trials, using black ink and layout paper, and ruling pencil lines at the correct x-height for each script and nib size. As the lines of poetry are long, a fairly small nib is required to prevent the final panel from becoming too large. You may need to try more than one nib size. Write out a few lines in each script and nib size to consider the texture and scale before making your final selection.
2a The main text trials: Italic, Foundational hand, and sloping capitals (two versions) using a Rexel no 3½ nib
2b The title trials: Italic, Foundational hand, Flourished capitals and Roman capitals using a Rexel no 2 nib

3 As the poem was intended for a child, a simple, easily legible script – Foundational hand – was selected. A sheet of layout paper was ruled up with the required x-height and an interline space of approximately 2 x-heights. The final interline space to be used can be judged at the next stage. The whole poem was then written out, the text cut up and arranged in lines on a background sheet of white card or thick paper, an aligned left layout selected for simplicity (with thumbnail sketch figure 1c in mind). Try moving the lines of text closer together and farther apart to judge an appropriate interline space. Two x–heights seemed appropriate for this project; the lines being separated sufficiently without being so wide apart that the text looks weak. The space between verses should be wide enough to give a marked visual break, but close enough to hold the poem together within the overall design. The title and credit writing trials were then cut out and placed on the layout for positioning. An informal, lively title was selected, with a shadow image in dilute gouache to add interest and light-heartedness. Capitals were chosen, to make a contrast with the main text, as they were for the credit (poet) to relate to the title lettering.

Small illustrations of four phrases from the poem – lines 4,7,8, and 13/14 – were sketched in pencil on 25mm (1in) squares on layout paper. These are to appear in the corners of the design. Simple buttercup motifs were sketched in pencil; these will form a simple border. The pencil illustrations were cut out and arranged on the text layout, ensuring that the buttercup motifs were equidistant. Because the right-hand side of the text is uneven, the placing of the buttercup motifs has to be carefully considered so that the space between the vertical text edge and the vertical line of motifs looks similar down both left and right edges. The margins were then assessed by placing four strips of coloured card around the work and ruled in. (See page 16 *General principles of layout – margins*.) Figure 3 shows a photocopy of the complete black and white rough.

I have a little shadow that goes in and out with me
And what can be the use of him is more than I can see
He is very, very like me from the heels up to the head

4a

I have a little shadow that goes in and out with me
And what can be the use of him is more than I can see
He is very, very like me from the heels up to the head

4b

MY SHADOW

ROBERT LOUIS STEVENSON

4c

4 Next, colour trials were made; first for the main text by writing out several lines in selected colours on layout paper. As green and blue predominate in the illustrations, these colours were selected for the writing trials. One trial (figure 4a) uses a method where the colour changes subtly within the lines of text. This is achieved by mixing green and blue gouache in separate compartments of the palette, and a mixture of the two in a third compartment. These colours are fed randomly into the pen with a brush each time it needs refilling. A second trial (figure 4b) uses blue only. This was selected as it has a quieter effect and there is enough visual interest provided by the decorative elements. Watercolour, on layout paper, was tried for the illustrations.

At this stage you will probably find it useful to make a complete colour rough on layout paper, ruling up and writing the main text first, then the title and credit and finally drawing and painting the illustrations. This enables you to ensure that the selected colour looks suitable on a large area of text in combination with the other decorative elements on the panel. This rough can be a paste-up.

4d

4e

4a Blue and green colour change
4b Blue only
4c Title and credit
4d Square illustrations
4e Border motifs

MY SHADOW

I have a little shadow that goes in and out with me,
And what can be the use of him is more than I can see.
He is very, very like me from the heels up to the head;
And I see him jump before me, when I jump into my bed.

The funniest thing about him is the way he likes to grow
Not at all like proper children, which is always very slow;
For he sometimes shoots up taller like an india-rubber ball,
And he sometimes gets so little that there's none of him at all.

He hasn't got a notion of how children ought to play,
And can only make a fool of me in every sort of way.
He stays so close beside me, he's a coward you can see;
I'd think shame to stick to nursie as that shadow sticks to me!

One morning very early, before the sun was up,
I rose and found the shining dew on every buttercup;
But my lazy little shadow, like an arrant sleepy-head,
Had stayed at home behind me and was fast asleep in bed.

ROBERT LOUIS STEVENSON

5 Select a paper with a hot-pressed surface and rule it up for the final version. Write the main text, heading, credit in that order, referring to the pasted-up rough. Then trace or copy the illustrations, having accurately marked the intervals for the border motifs. Paint the illustrations and border. Mark in the margins.

Greetings card

Designing a greetings card is an ideal project for a calligrapher in the early learning stages. As it uses just a few words, it is possible to combine lettering and design in an easily manageable and effective way. A short text enables you to maintain consistent lettering and allows a lot of scope for playing with design ideas without lengthy re-writing each time. As you gain experience, you may wish to make a design using a longer text. Do not settle immediately for the first idea but explore other possibilities; this encourages design awareness.

You can design individual cards, working from your paste-up rough and using colour on a good quality paper. You can also prepare pasted-up artwork for photocopying or printing by offset-litho. The card can incorporate illustration or decoration if required. For personal use, printed cards are usually one colour for reasons of economy, but you can add a symbol, word or other decoration in further colours by hand after printing. This enhances the design and gives an additional personal touch.

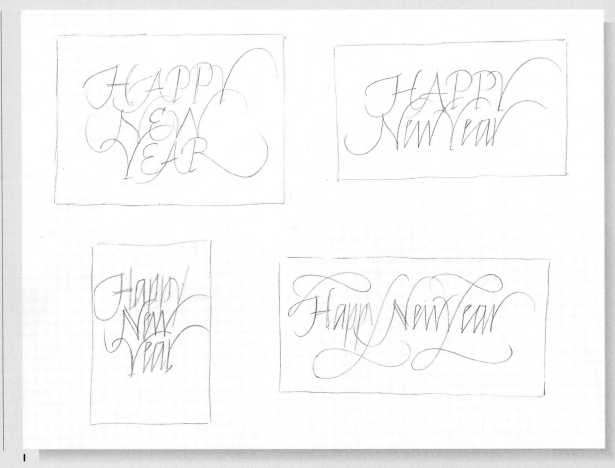

1

1 Freely sketch some initial ideas in pencil. This will ensure that you are not 'put on the spot' by a blank sheet of paper when you begin writing with a pen. You will already have established the basic elements of your design.

Hand written cards can be presented in many exciting ways, other than the simple single fold. Try designing cards to be folded in some of the ways illustrated. Concertina folds can be attractively presented with thin ribbon ties. A wide range of beautifully coloured and textured papers can further enhance the sensitivity of your design. Complicated folds and exotic papers can be prohibitively expensive, though, when printing.

a Horizontal concertinas in three styles
b Vertical concertina
c Two-fold horizontal
d Two-fold concertina

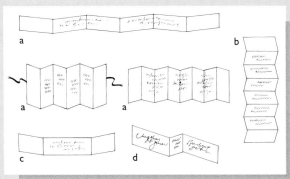

HAPPY NEW YEAR

2a

HAPPY New Year

2b

HAPPY new year

2c

Happy NEW YEAR

2d

Happy New Year

2e

2 Having made the thumbnail pencil sketches, you should have some ideas for the lettering styles you wish to try. You need to decide the scale at which to work in order to select suitable pen sizes. If you are designing for a hand-written card, you will have to make your rough paste-up the same size as the finished card. If you are designing artwork for printing, you can work same size or larger as long as it is to scale with the required finished card size. (See page 20 *Useful processes – Figure 1.*) Make writing trials of the text on layout paper in black ink, ruling up the correct x-height for the different writing styles and pen sizes. These first pen trials can be to a specific layout, if you have one clearly in mind.

It is easier to write the text on straight lines and then cut it up to try different layouts. Try both horizontal and vertical layouts unless you have a particular preference for the shape of the card. When a layout is satisfactory, paste up the lettering with rubber cement solution on white card. (See page 20 *Useful processes – Pasting up.*) Take care to align all the elements accurately and to ensure that the glue does not get onto your fingers or the top surface of the photocopied elements. Decide on the size and position of the margins by placing four coloured strips of card or paper round the design, moving them in and out to compare results. Rule in the outer margins in pencil. If you are preparing artwork for printing, mark the outer corners of the margins with crosses as reference for the printer.

2f

HAPPY NEW·YEAR

2g

2a Flourished capitals
2b Flourished capitals and Italic
2c Flourished capitals and Uncial
2d Mixed letterforms
2e Flourished Sharpened Italic
2f Mixed letterforms, heavy and lightweight.
2g Flourished double-stroke capitals

95

3 If there is printed text to go on the inside page of the card, as in the example shown here, make writing trials for this. The style trials shown here, from the top downwards, are:
Cursive Italic
Sharpened Italic
Flourished Italic
Cursive Italic with a low x-height
Foundational hand
Uncial
Sloping capitals
Flourished capitals

4 Draw an outline the same size and shape as the front of the card. Cut up and paste the inside text into this layout to ensure that it is to scale and fits the space with adequate margins.
4a Horizontal layout, Italic
4b Vertical layout, Italic
4c Vertical layout, flourished capitals

Margaret and Bob Parr
wish you health, happiness & prosperity
in the coming year

4a

Margaret and Bob Parr
Margaret and Bob Parr
Margaret and Bob Parr
Margaret and Bob Parr
Margaret and Bob Parr
MARGARET AND BOB PARR
MARGARET AND BOB PARR
MARGARET AND BOB PARR

3

Margaret and Bob Parr
wish you health,
happiness & prosperity
in the coming year

4b

MARGARET AND BOB PARR
WISH YOU HEALTH,
HAPPINESS & PROSPERITY
IN THE COMING YEAR

4c

Margaret and Bob Parr
wish you health,
happiness & prosperity
in the coming year

HAPPY NEW YEAR

5

5 If you are preparing artwork for printing and you have text to be printed on the inside of the card, you need to paste up the designs for both the front and the inside on one sheet of card. (It is more economic for them be printed at the same time from one sheet.) Solid blue lines show the outside dimensions of the opened-out artwork, broken blue lines show where the card will be folded after printing. Write instructions to the printer concerning how much the artwork should be reduced, if at all.

6a

6b

6c

Margaret and Bob Parr
wish you health, happiness & prosperity
in the coming year

6d

Individual hand-made cards

If you are making individual cards by hand, the procedure is the same as for printed cards up to the end of stage 3. Then make written colour trials on layout paper to establish your colour scheme. You might like to try using coloured paper or masking fluid for different effects.

7 When you have decided on your colour scheme, select the paper for the final version. The text here is written in masking fluid on a 300 gsm hot-pressed paper. When the masking fluid is dry, apply the watercolour wash (see page 22 *Writing over coloured backgrounds* for hints on applying washes). When the paint is dry the masking fluid can be rubbed off. Addressing the envelope in an attractive way can add a final personal touch to the presentation of the card.

7a Masking fluid partially removed.
7b An example of a finished card using masking fluid and watercolour wash

Facing page
6 Finished printed cards:
6a One colour
6b One colour reversed out – using the same artwork, the design is photographically reversed (that is, black becomes white, and white becomes black on the artwork). It can be printed in any colour you choose. Your printer can do this for you.
6c One colour
6d Printed inside to 6a or 6b.

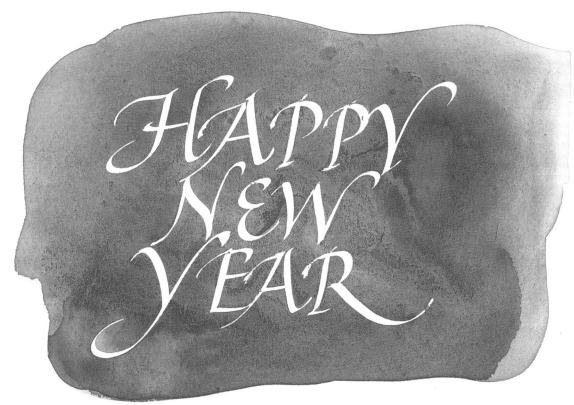

Menu

A menu is a practical project for those new to calligraphy. It puts all your lettering and design skills into practice: the selection of appropriate writing styles, sizes, line spacing, layout and colour. The wide choice of calligraphic scripts allows you to produce a design that is specific to the particular requirements of the occasion. You will need to prepare black and white pasted-up artwork for offset-litho printing. If the menu is for a day-to-day use in a café or restaurant, one-colour printing would probably be required for economy. A menu for a special occasion, such as a wedding or banquet, may require more than one colour printing. For a first project of this type, it is best to design for one colour printing. If a second colour is essential, ensure that design elements in different colours do not overlap or touch, so that the artwork can be pasted up on a single sheet. Consult your printer about costs before starting the project.

1a

1b

1 Obtain accurate text from the client and discuss presentation requirements: is it to be a one sheet menu or separated into courses on more than one page; folding or separate sheets; size and format, for example. Consider the wording and make pencil thumbnail sketches of initial design ideas (figures 1a, b), bearing in mind any instructions concerning page shape. Your initial thumbnail sketches may use the actual wording, as illustrated, or may just be pencil lines sketched in to show placement of the lines of text.

Silver wedding of

SILVER WEDDING OF

Silver wedding of

SILVER WEDDING OF

2a

John & Judith Leverton

John & Judith Leverton

JOHN & JUDITH LEVERTON

John & Judith Leverton

2c

Champagne Cocktails

Champagne Cocktails

Champagne Cocktails

Champagne Cocktails

2b

Champagne Cocktails Smoked Salmon Canapés

Chilled Vichysoisse Prawn Cocktail Bœuf en Croûte

3

2 Try to envisage how the final menu might look in more detail than in your first thumbnails and note any ideas about suitable scripts. Consider the writing style – strong or light and delicate, wide or compressed. Also note whether you want any of the design elements, such as headings, in a different script and size from the main body of the text. Remember that in designing any artwork for print you can work larger than the required final printed size as long as it is in proportion. (See page 20 *Useful processes*.) Try out a few words in ink on layout paper, using different styles and sizes, ruling double lines in pencil at the required x–height for each script and nib size. As the menu illustrated here was for a private special occasion, a more decorative quality was tried for the names of the hosts.
2a Different Italics and capitals
2b Different Italics and Foundational hand
2c Different Italics, capitals and Foundational hand.

3 When you have decided on the style of writing for each of the design elements, rule up the appropriate x–height on layout paper and write out the main text. A no 3½ Rexel (Mitchell's nib) was used here. The layout shown here was obviously going to be over-long and narrow because of the long list of items on the menu. Therefore, a fairly wide Cursive Italic was chosen to widen the design. Write out the headings and any other information, in appropriate styles and sizes, to harmonize but contrast with the main text.

Cut up the lines of writing and arrange them in a layout on a sheet of white card. A centred layout was chosen here to accommodate long and short lines. Move the lines closer and farther apart to judge the most suitable line spacing. If you are working larger than the final printed menus, draw the final menu size on a sheet of layout paper and project the diagonal to check that you are working to the correct proportions. (See page 20 *Useful processes* – figure 1.) Do not paste up at this stage.

4a

4b

4 If any additional design elements are required, such as decorative motifs, make trials of these on layout paper. Cut out the selected elements and place them on your layout with the text. Decide if they are the right size to work well in the design with the main text and if not, rework them until you are satisfied.

4a Colour trial of the heading
4b Colour trials of the motifs

5 Paste up the layout with rubber cement solution to produce final artwork. (See page 20 *Useful processes – pasting up*.) If the menu is to be printed in colour, now is the time to make trials of any text you may wish to have printed in a different colour. Place these in position on the artwork to check that they look right.

Place four coloured strips of card around the design and move them in and out to assess margins. Adjust the margins and line spacing, if necessary, to get the height and width proportions of your artwork exactly right. When working oversize, use the extended diagonal method mentioned in step 4 . Mark in the outer corners of the artwork with crosses as trim marks for the printer. Indicate on an overlay sheet any instructions to the printer about reduction and colour requirements.

SILVER WEDDING OF

John & Judith Leverton

LUNCH MENU

Champagne Cocktails
Smoked Salmon Canapés

Chilled Vichyssoisse
Prawn Cocktail

Bœuf en Croûte
Curried Chicken
Lobster Thermidor
Mushrooms à la Grecque
Pommes Dauphinoises
Mixed Herb Salad

Pavlova with Mixed Fruits
Strawberry Shortcake
Tarte Tatin

Selection of Cheeses

Coffee

5

6 Check the final printed menu (2-colour offset-litho) before delivering it to your client — mistakes can occur!

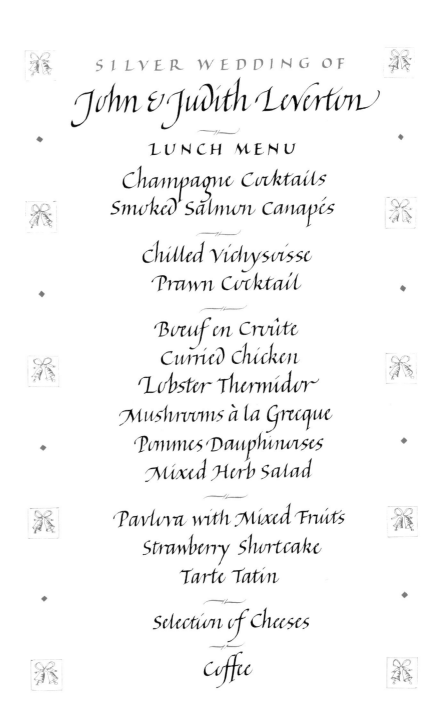

SILVER WEDDING OF

John & Judith Leverton

LUNCH MENU

Champagne Cocktails
Smoked Salmon Canapés

Chilled Vichyssoisse
Prawn Cocktail

Bœuf en Croûte
Curried Chicken
Lobster Thermidor
Mushrooms à la Grecque
Pommes Dauphinoises
Mixed Herb Salad

Pavlova with Mixed Fruits
Strawberry Shortcake
Tarte Tatin

Selection of Cheeses

Coffee

Certificate

Calligraphers are often required to fill in names and dates on printed certificates. They may also be asked to design certificates – individually hand-written if the numbers are small and the budget will permit, or as artwork for printing when numbers are large. A certificate is interesting to design as harmony of style, size and colour in the writing is essential. The important considerations are the suitability of scripts and layout for the subject, the order of importance of the information and the appropriate use of colour (usually the titles of societies and the recipients' names will need to feature prominently). Any use of colour must be established at the rough stage, even though the final artwork prepared for printing is presented in black and white. Often recipients' names are inscribed in colour and the style, weight, size and colour of this element must be resolved at the same time as the rest of the certificate is designed, to ensure adequate space is allowed and that it harmonizes with the rest of the design.

1a

2a

1b

1 Consider carefully the nature of the award, as this may suggest some scripts as being more appropriate than others. Consult the client about any preferences for format – whether horizontal or vertical. Make thumbnail pencil sketches of first design ideas.

2 Try scripts in a number of sizes and styles, ruling up the appropriate x–height on layout paper and writing in black ink. Start with scripts you consider to be suitable for the main body of the text, and then make trials of scripts for the remaining elements.
2a Capital, Italic and Foundational hand (two versions)
2b Italic, plain Italic capitals, Flourished capitals

2b

Primrose Hill Junior School · Swimming Certificate

BRONZE MEDAL FOR LIFESAVING

This is to certify that

MARY-JANE EDWARDS

has passed Grade 9 of the National Swimming Association
and has thus been awarded the Bronze Medal for Lifesaving

PETER EDWARDS

SWIMMING INSTRUCTOR NATIONAL ASSOCIATION OF SPORTS TEACHERS

JUNE·12·1994

3

3 Having selected styles and sizes, rule up double lines at appropriate x–heights on layout paper. Write out the full text. In this certificate, the formal nature of Foundational hand makes it suitable for the main text, which has been written with a no 3 Rexel (Mitchell's) nib. Subtle Flourished capitals, written with a no 2 Rexel (Mitchell's) nib, were selected for the important information – 'Bronze Medal for Lifesaving' – making it the focal point of the design. A larger scale and heavier weight Foundational hand, using a no 2 Rexel (Mitchell's) nib, was selected for the recipient's name, to give it prominence and to tie it in with the Foundational hand of the main text.

(This name will, of course, be omitted from final artwork.) Small capitals were chosen for the information at the base of the certificate to relate to the capitals used elsewhere. They were written using no 4 and no 6 Rexel (Mitchell's) nibs. A decorated Uncial was used for 'Swimming Certificate', to give added design interest and make it distinctive yet unite with the roundscript used elsewhere. The decorated Uncial and Flourished capitals add interest to the design in the absence of any badge or illustration.

Cut the writing into lines and arrange them on a background sheet of white card, trying different layouts and interline spacing. Break the text lines

into meaningful phrases: here a centred layout successfully integrates long and short lines into the design. Generous vertical spaces separate the different design elements and elongate the design into a satisfactory vertical shape. (Figure 3 shows a possible alternative layout – lateral format, using the same weights, styles and sizes of script.)

When a layout is satisfactory, paste up the text using rubber cement solution, checking that the proportions of the certificate accurately relate to the required final printed size. Do this by drawing the required size of the printed certificate on a sheet of layout paper and projecting the diagonal. (See page 20 *Useful processes – pasting up.*)

SWIMMING CERTIFICATE

MaryJaneEdwards

4

4 Make colour trials for any design elements you wish to be in colour and place these on the layout to check that they harmonize with the rest of the design.

5

5 Assess the margins. (See page 16 *General principles of layout – assessing margins*.) Ensure the artwork is in proportion to the required printed size and mark in the corners with crosses as trim marks for the printer. Write any instructions to the printer on an overlay sheet.

Primrose Hill Junior School

SWIMMING CERTIFICATE

BRONZE MEDAL FOR·LIFESAVING

This is to certify that

has passed Grade 9 of the National Swimming Association and has thus been awarded the Bronze Medal for Lifesaving

PETER EDWARDS

SWIMMING INSTRUCTOR
NATIONAL ASSOCIATION OF SPORTS TEACHERS

JUNE·12·1994

6 If names are to be written centred on the printed certificates, it is usually necessary to write them on layout paper first to ascertain their width. Figure 6 shows the printed certificate with a name inscribed in red by hand.

Primrose Hill Junior School

SWIMMING CERTIFICATE

BRONZE·MEDAL FOR·LIFESAVING

This is to certify that

Mary Jane Edwards

has passed Grade 9 of the National Swimming Association and has thus been awarded the Bronze Medal for Lifesaving

———————————

PETER EDWARDS

SWIMMING INSTRUCTOR
NATIONAL ASSOCIATION OF SPORTS TEACHERS

JUNE·12·1994

Letterhead

A calligraphic letterhead or one combining calligraphy and type can be attractive and offers good design scope. This is a very suitable project for beginners who can design letterheads for their own use. The beginner's choice of letterforms and design possibilities are more limited, but a well-written simple design can be very pleasing.

You must consider what 'image' is appropriate to the individual or business requiring the letterhead. Whether an exuberant design for a fashion shop or a more classical image for an antiquarian bookshop, there are numerous possibilities for each letterhead design. Sometimes there may be an illustration to incorporate, or a client may require you to design this element, too. These provide a useful design focus.

A letterhead has to be printed, so black and white paste-up artwork must be produced for the printer. It is usually printed by offset-litho in one colour for economic reasons, except perhaps where an illustration includes one or more colours, or a client requires more than one printing colour.

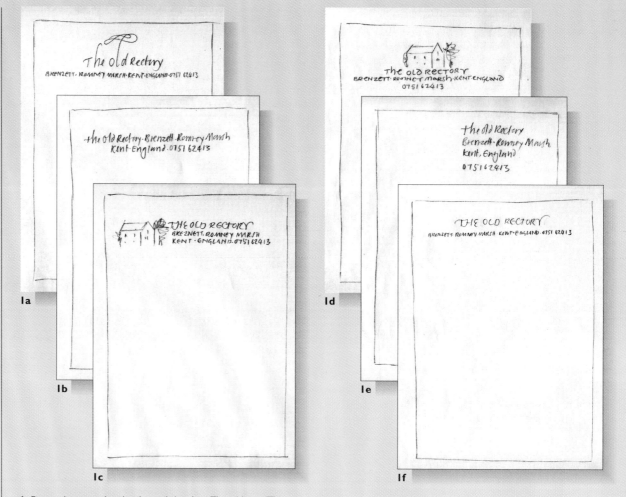

1a

1b

1c

1d

1e

1f

1 First make some thumbnail pencil sketches. The address, 'The Old Rectory', suggests a restrained design, although there is still plenty of scope for both letterform and layout. There is no fixed number of thumbnail sketches; it will vary from project to project. The purpose is to get some spontaneous ideas down on paper as a starting point, to be followed by several stages of design refinement. The inclusion of an illustration may depend on the client's preference if the letterhead has been commissioned. If a building needs to be illustrated, you can save time and money by using a photograph as a reference. Several thumbnail sketches were made for this project (figures 1a, b, c, d, e, f,).

The Old Rectory, Brenzett, Romney Marsh,

The Old Rectory, Brenzett, Romney Marsh

The Old Rectory, Brenzett, Romney Marsh,

The Old Rectory, Brenzett, Romney Marsh,

THE OLD RECTORY, BRENZETT, ROMNEY MARSH,

THE OLD RECTORY, BRENZETT, ROMNEY MARSH,

THE OLD RECTORY, BRENZETT, ROMNEY MARSH,

2a

The Old Rectory

The Old Rectory

THE OLD RECTORY

THE OLD RECTORY

THE OLD RECTORY,

2b

2 For the first writing trials a number of scripts and nib sizes were tried, using black ink and layout paper. The final printed size was to be A4, that is, 297 x 210mm (11¹¹⁄₁₆ x 8¼in), so the pen sizes were kept fairly small in order to produce pasted-up artwork no larger than A3, that is, 420 x 297mm (16½ x 11¹¹⁄₁₆in). Otherwise, the lettering would have been too thin after photographic reduction by the printer. The trials for the address were written in Rexel 3½, 4 and 5 nibs, and some additional trials for 'The Old Rectory' were made using a 3 nib for emphasis of scale.

2a A variety of Italics – Formal, Flourished, Sharpened, and Cursive. Capitals – sloping, upright, and Uncials.

2b Italics – Formal, Sharpened, Flourished capitals, Uncials, and plain capitals.

3 Any decorative element must be designed at this stage. The scale of the illustration is important; it should not be too overpowering. The illustration included in this project was first drawn in pencil from a photograph and then inked in. Several different sizes of illustration were obtained by reducing on a photocopier. The straight ink lines used in two of the designs were drawn with a ruling pen and straightedge (or ruler). If the subject is beyond your drawing skills, it can be traced onto layout paper and photocopied to the right size, but apply the ink slowly to avoid the paper's buckling when it dries.

3

The Old Rectory

BRENZETT, ROMNEY MARSH, KENT, ENGLAND · TEL· 0751 62413

4a

THE OLD RECTORY, BRENZETT, ROMNEY MARSH,
KENT, ENGLAND · TEL · 0751 62413

4b

The Old Rectory, Brenzett, Romney Marsh,
Kent, England · Tel · 0751 62413

THE OLD RECTORY
BRENZETT, ROMNEY MARSH,
KENT, ENGLAND · TEL · 0751 62413

4c

The Old Rectory, Brenzett, Romney Marsh,
Kent, England · Tel · 0751 62413

4d

THE OLD RECTORY
BRENZETT, ROMNEY MARSH, KENT, ENGLAND
TEL· 0751 62413

4 If you are working to the same size as the final printed letterhead, the writing trials can be cut up, arranged and pasted up on A4 sheets of paper so that you can assess the layouts at the proper scale. If you are working to a larger scale, it is helpful to reduce your writing trials to the appropriate sizes so that trial layouts can be arranged on A4 sheets. In this project, the writing trials were reduced by photocopying by 20%, 30% and 50% to give more choice of writing sizes for making the layouts. Try different styles and sizes of lettering on each layout before pasting up, to get a satisfactory combination (figures 4a, b, c, d, e, f).

Try different working methods when approaching layout. One method is to work on one layout at a time, trying different sizes and placement of text until a satisfactory layout is achieved, and then paste up. Another is to have a number of layouts spread out, each on a separate sheet, and try different styles and sizes of writing on each, moving the text around and comparing layouts. It is helpful having this comparison of designs available as you work. Paste up designs as they become resolved.

4e

4f

THE OLD RECTORY
BRENZETT, ROMNEY MARSH,
KENT, ENGLAND · TEL · 0751 62413

5

5 When the preferred layout has been selected, final pasted-up artwork must be prepared for the printer. If you used photocopied reductions of your writing trials in your roughs, the original calligraphy must be pasted up on a sheet of white card in the required layout and to scale with the proportions of the final printed sheet. (See page 20 *Useful processes – Pasting up.*) This will ensure the best quality in the final printed job.

Mark up the artwork for the printer by ruling crosses in all four corners as trim marks to show the outer margins of the design. Include instructions on an overlay sheet of layout paper, indicating the degree of reduction required and any colour specifications. You may simply state 'reduce height to A4' or whatever size you require. As a final check on the proportions, photocopy your artwork down to the required size.

6 A colour is usually selected from the printer's colour reference chart, although if the client requires a colour rough, this can be written in gouache on layout paper (figure 6a, b, c). Most letterheads are one colour, although printing in more than one colour is possible. As long as the different colours do not touch or overlap, the artwork can be pasted up on one sheet. In designs where colours do touch or overlap, the artwork for each colour must be pasted-up on separate sheets or a tracing film overlay. They must be in perfect alignment with each other. This is done by 'registering' the crosses marked in each corner of the artwork sheets so that when they are in alignment, so too are the elements of the artwork.

The choice of paper colour, weight, and surface finish is another important consideration, which should be discussed with your client. The printer usually has samples and can advise on this.

6b

6a

6c

7

7 The finished letterhead, printed on a laid paper with a subtle grey and red fleck in it. *(shown at actual size, top third only.)*

Poster

Hand-lettered posters are all around us, in town and village alike, and good calligraphy contributes to making them attractive. A poster should be interesting, eye-catching, easy to read and uncluttered. The lettering and design should be appropriate to the subject. The relative dominance of different parts of the text should be in keeping with the importance of the particular information. The number of posters required and the budget will influence the time spent on the design and the print process selected (whether offset-litho or photocopying). A poster for a local function, such as the project illustrated here, would have a low budget and probably be reproduced by photocopying. This is the type of poster calligraphers are most frequently asked to produce. The possibilities of photocopying lettering in a colour and the use of coloured card widen the design scope of a low budget poster. An illustration can make an arresting focal point on a poster or the lettering itself can serve this design function through emphasis of scale or weight.

Designing a poster is an interesting challenge at any stage in your calligraphic development: even a beginner can create an interesting design through the use of contrasting lettering styles, size, weight and movement.

The poster shown here is for a small local event and, as the number required and the budget are low, has been designed for reproduction in one colour photocopying. Such design limitations must be considered from the outset.

1a

1b

1c

1d

1 Make thumbnail pencil sketches of design ideas. Although at this stage you may not know exactly which scripts you will use for all the text, you will probably have some ideas about how you can present the most important information. As there was nothing specific to illustrate, it was decided to make the lettering stand alone, and to create interest using contrast within the lettering itself. Both vertical and lateral layouts were possible (figures 1a, b, c, d,).

2 Decide approximately what scale you will work at by considering the final poster size. For an A4 poster, it can be same size or larger (as long as it is in proportion). Draw a scale diagram so you can check that the design is to scale as you work on the layout. (See page 20 *Useful processes - pasting up.*) Experiment with ideas for the title in different styles and nib sizes, using black ink on layout paper. In these examples an automatic pen was used for the large Italic 'winter' and Rexel (Mitchell) nibs of various sizes for the other information. The relative importance of each section of information will influence your decision when choosing styles and nib sizes. While you need to create contrast and interest, the design must be coherent and not have too many different elements. Capitals at different sizes are used in this design to indicate the hierarchy of the information, while the similarity of writing style helps to harmonize the design.

2a Flourished Italic and capitals, double and triple stroke versals

2a

CHARITY SALE

CHARITY SALE

CHARITY SALE

CHARITY SALE

CHARITY SALE

CHARITY SALE

CHARITY SALE

2b Various capitals showing different weights, letter widths, and sizes
2c Alternative possibilities – Italic, and small capitals written in masking fluid and covered with an ink wash

2b

William Ellis School, Haverstock Hill, Rochester
Sunday, November 5, 1994
ALL PROCEEDS TO THE UNITED NATIONS CHILDREN'S FUND

2c

3 Cut up the writing trials and arrange them on a background sheet of white card, trying different layouts. Any text that does not look appropriate in the design can be rewritten in a different style or size. Pay attention to the interline space as you try different layouts. Place four strips of coloured card around the design to assess the margins and adjust these and/or the interline space as necessary, to make the overall design in proportion to the finished poster. Check this with the scale diagram.

Paste up the final layout. Figure 3 shows the cut and pasted-up artwork ready for printing. A3 size, that is 420 x 297mm (16½ x 11¹¹⁄₁₆in). If the poster is to be printed rather than photocopied, write instructions to the printer on an overlay sheet attached to pasted up artwork.

3

WILLIAM ELLIS SCHOOL,
HAVERSTOCK HILL ROCHESTER

SUNDAY, NOVEMBER 5,
1994

OPEN FOR CARS 9AM ONWARDS
OPEN TO PUBLIC 10·30AM

ALL PROCEEDS TO THE UNITED NATIONS CHILDREN'S FUND
ENQUIRIES: William Ellis Parent Teachers Association
071 62 1990

4 If, as here, colour is required in the writing, it is useful to make colour trials or even a complete colour rough to show the overall effect. Turquoise was chosen for this poster, as it is a 'cold' colour, appropriate to the subject. If you are producing only a very small number of posters it is worth bearing in mind that you can add colour by hand after printing.

4

5 The finished poster.

WINTER
CHARITY SALE

WILLIAM ELLIS SCHOOL,
HAVERSTOCK HILL ROCHESTER

SUNDAY, NOVEMBER 5,
1 9 9 4

OPEN FOR CARS 9AM ONWARDS
OPEN TO PUBLIC 10·30AM

ALL PROCEEDS TO THE UNITED NATIONS CHILDREN'S FUND
ENQUIRIES: William Ellis Parent Teachers Association
071 62 1990

Poem – *The Tiger*

Writing out poetry or a short piece of pleasing prose is a widely enjoyed aspect of calligraphy – by both calligrapher and viewer. Although the potential of calligraphy is becoming increasingly recognized in the area of graphic design and much of the work of today's calligraphers comes from this direction, writing out literary quotations remains an important part of the craft. There is a vast range of creative possibilities. One way is to write the words in a traditional script, using a simple layout and following the original poem line for line. An alternative is to create a painterly rendering with background washes, perhaps splitting the poem up with different line breaks

A well-written calligraphic panel will always be appealing. A straightforward approach to layout and design, concentrating on sound lettering, is recommended for the beginner. Exploring different ways of conveying the text calligraphically will follow naturally from such beginnings. Interpreting prose and poetry is a wonderfully rich area for creative calligraphy.

A simple aligned left layout has been chosen for William Blake's poem *The Tiger*. This can easily be managed by the inexperienced calligrapher.

1a

1b

1c

1 When you are using a simple layout, the line and verse lengths of the poem will suggest the shape of the panel. If it is a short poem, particularly one with long lines, it will tend towards a horizontal layout. If, as here, it is long, it will tend to a vertical arrangement. The interline spacing you choose will also affect the shape of the layout. Before making thumbnail pencil sketches of layout possibilities (figures 1a, b, c), read the words carefully. Investigate different types of script as a way of reflecting the meaning or emotion of the poem. (See pages 16-17 *General principles of layout*.) Although centred and asymmetrical layouts are popular and can produce interesting results, a straightforward aligned left structure has been chosen for this project. Not only is it simple, it is also attractive and effective, and was much used for classical poetry in fine Renaissance manuscripts. We are, of course, also used to seeing aligned left layouts in printed books of poetry.

2a

Tiger, tiger, burning bright

Tiger, tiger burning bright

Tiger, tiger, burning bright

Tiger, tiger, burning bright

TIGER, TIGER BURNING BRIGHT

TIGER, TIGER, BURNING BRIGHT

TIGER, TIGER, BURNING BRIGHT

TIGER, TIGER, BURNING BRIGHT

2b

The Tiger

THE TIGER

THE TIGER

THE TIGER

THE TIGER

THE TIGER

2c

William Blake

WILLIAM BLAKE

WILLIAM BLAKE

2 Consider the scale of the finished panel, as this will affect your choice of nib sizes for your writing trials. Having decided the approximate scale, write the first line or two in a number of different scripts and nib sizes to get a feeling for the poem and which script suits it best.

2a Main text: Italic (three versions), Foundational hand, Uncial, capitals (three versions)

2b Title: Italic, Italic capitals (five versions).

2c Credit: Italic, Italic capitals (two versions).

Tiger, tiger, burning bright
In the forests of the night
what immortal hand or eye
Could frame thy fearful symmetry

3 Select the style and size of nib you prefer and write out the entire text on layout paper in black ink, ruling up at the correct x-height for the particular script and nib size. A Rexel no 3 nib was used for the main text. The interline space is not important at this point, as the text will be cut into lines for layout purposes. However, 1¾ or 2 x-heights spacing is advised for the first writing out: this distance generally works well with a minuscule script, giving enough clearance for ascenders and descenders. Write out the title and the name of the poet (the credit). A Rexel no 2 nib was used for the title and a 4 for the credit.

4 Cut the text into lines and arrange it, in an aligned left layout, on a background sheet of white card or thick paper. Move the lines closer and farther apart to gauge a suitable interline space. The layout must allow clearance of ascenders and descenders but not be so generous that the poem appears to fall apart vertically. 1½ x-heights was selected for this poem to make the lines hold together strongly; the mood of the poem being one of strength. When a layout is satisfactory, paste up with rubber cement solution. Assess margins round the text. (See page 20 *Useful processes* for paste-up method, and page 16 *General principles of layout* for assessing margins). Because the first three lines of the poem are short, there is rather a 'hole' in the design at the top right-hand corner, so the poet's name was positioned on the top line next to the title, rather than underneath the poem, to redress the balance of the design.

Colour is the next consideration. Here it was decided to keep the writing in black, but to introduce ochre into the panel by scraping some conte crayon with a knife and rubbing it into the background. You can try various colours on the pasted-up rough.

THE TIGER WILLIAM BLAKE

Tiger, tiger, burning bright
In the forests of the night
what immortal hand or eye
Could frame thy fearful symmetry?

what the hammer? what the chain?
In what furnace was thy brain?
what the anvil? What dread grasp?
Dare its deadly terrors clasp?

In what distant deeps or skies
Burnt the fire of thine eyes?
On what wings dare he aspire?
what the hand dare seize the fire?

When the stars threw down their spears,
And water'd heaven with thy tears,
Did He smile His work to see?
Did He who made the lamb make thee?

Tiger, tiger, burning bright
In the forests of the night
What immortal hand or eye
Could frame thy fearful symmetry?

5 The nature of the poem suggested buff coloured Indian handmade plant paper. A verse was written on this to see the effect of black lettering on this colour background, and a few touches of ochre conte crayon were added. This was selected in preference to the white paper.

6

6 For the final version, rule a left margin and double lines to contain the letter bodies at the correct x-height for the script and nib sizes. When you are more experienced and can maintain the x-height satisfactorily by eye, you may prefer to write on a base-line only. Usually, conte crayon would be applied to the background before writing, especially if there is a lot, and sprayed with fixative. However, if the conte crayon touches are minimal, as in this project, they may be added after writing. Fix the finished poem with spray.

THE TIGER WILLIAM BLAKE

Tiger, tiger, burning bright,
In the forests of the night,
What immortal hand or eye
Could frame thy fearful symmetry?

In what distant deeps or skies
Burnt the fire of thine eyes?
On what wings dare he aspire?
What the hand dare seize the fire?

.

What the hammer? what the chain?
In what furnace was thy brain?
What the anvil? what dread grasp
Dare its deadly terrors clasp?

When the stars threw down their spears,
And water'd heaven with their tears,
Did He smile His work to see?
Did He who made the lamb make thee?

.

Alphabet design

Making a design with the alphabet is always an interesting challenge. Whatever your proficiency in calligraphy, it is a useful project with such diverse possibilities that it offers enormous scope. The process of selecting and rejecting design elements builds your creative judgement. This type of project is likely to be purely for yourself, so it is a very good vehicle for experiment and play – an essential part of learning calligraphy.

Whether you are planning a small delicate alphabet or a large wall panel, the same design process – working from thumbnail sketches, through colour rough, to final version – is employed. The alphabet offers huge scope for design treatments. Experiment with a rich choice of writing styles, singly or in combination, different scales of lettering, static or moving letters, black and white or colour (subtle or vibrant). Whether your intention is a fine-tuned classical alphabet, perhaps of Roman capitals, or a lively design with dancing letters overlapping in an interwoven texture of different colours, each design is unique. When you feel ready, try using automatic and coit pens or other writing tools, such as ruling pens and balsa wood pens in your alphabet designs.

In the design illustrated here a combination of formal and flourished scripts has been chosen to give a contrast of movement within the design.

1a

1c

1b

1d

1 Make thumbnail pencil sketches of design ideas on layout paper (figures 1a, b, c, d). In this case, it was decided from the outset to make this alphabet design small-scale and colourful.

2a

ABCDEFG
ABCDEFG
ABCDEFG
ABCDEFG
abcdefg
abcdefg

2 Having in mind a rough idea of the scale of the final design, make writing trials of different scripts in black ink on layout paper, ruling up at the correct x-height for each script. The thumbnail sketch chosen combines two scripts around a rectangle with slightly dished sides. The sides may be straight, if preferred, for ease of painting. The capitals are written with a Rexel no 3 nib and the italic with a 5, the different styles and sizes being selected for contrast. Other scripts can, of course, be used to obtain different effects.

2a Different single scripts: Roman capitals, Flourished Roman capitals, Italic capitals, Flourished Italic capitals, Italic, Foundational hand.

2b Combined scripts: Flourished Roman capitals and Italic, Roman capitals and Foundational hand, Flourished Roman capitals and small Italic.

2c 'A's and 'Z's for the centre of the design: Roman capitals, Flourished Roman capitals.

3

2b

AbcdEFG
AbcdEFG
AbcdEFG

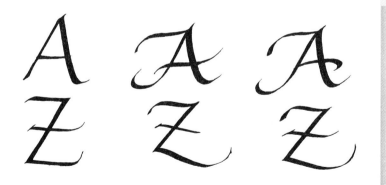

2c

3 Once you have decided on the scripts, the next stage is to write out all the design elements in black ink on layout paper, cut them up and arrange them in a rectangular shape on a background sheet of white card. When the arrangement of letters fits in satisfactorily, paste them up. Assess exactly how much space to allow between the lettering and the rectangular boxes, and draw them in pencil. Now add any extra decorative elements, such as the small rectangles at the corners.

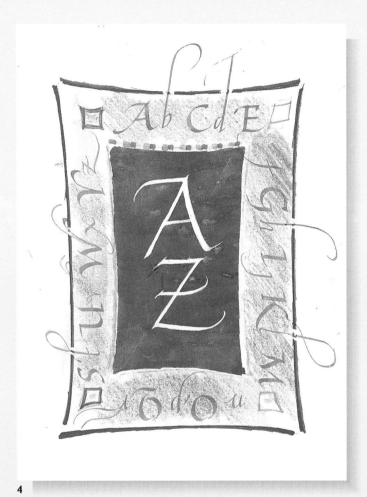

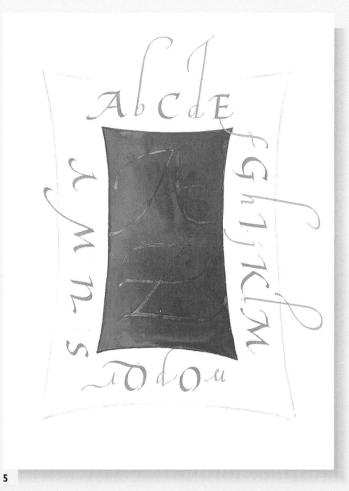

4

5

4 The next stage is to decide on a colour scheme. Masking fluid is used for the 'A' and 'Z' in the centre of this design and, when dry, a colour wash is painted over it. Gouache was used to obtain an opaque, strong colour effect. (See page 25 *Resist Technique* for details of using masking fluid.) Try the writing in a number of colours and also experiment with background colours before making your final colour rough of the whole design on layout paper

5 To make a finished version, select a good quality paper – say, 300 gsm hot-pressed – and trace the two rectangles, allowing plenty of surrounding white space. Lightly pencil in the centre and surrounding lettering. It might help if you first draw faint lines to show the position of the letters.

Write the centre lettering in masking fluid using a Rexel no 2 nib.

When the masking fluid is dry, the edges of the inner rectangular shape can be painted in and a wash applied over the masking fluid letters, some in gouache and some in watercolour to create a graduated colour effect. Next, write the surrounding lettering, the capitals in turquoise, leaving gaps for the small italic which can then be written in green.

6

6 Draw the small motifs in the corners. Paint the motifs and the lines defining the outer rectangle, leaving breaks where the flourishes cross through. Scrape a conte crayon of suitable colour with a knife and lightly rub the powder into the space surrounding the lettering to make a soft background tint. Additional colour can be added with pencil crayons. However, if the lettering is in pale colours, you will need to apply the conte crayon and pencil crayon before writing. Otherwise, the crayon will discolour the lettering. It is easier to write on the clean paper, so avoid this, if possible.

7 Spray the design with fixative and carefully rub the masking fluid from the lettering in the centre.

7

Index